FOREST VOICES

FOREST VOICES

Compiled by
HUMPHREY PHELPS

AMBERLEY

This edition published 2008

Amberley Publishing
Cirencester Road, Chalford
Stroud, Gloucestershire, GL6 8PE

www.amberley-books.com

British Library Cataloguing in Publication Data.
A catalogue record for this book is available from the British Library.

ISBN 978-1-84868-032-6

Typesetting and origination by Amberley Publishing
Printed and bound in Great Britain

CONTENTS

INTRODUCTION

This book is about life and work in the Forest of Dean during the first half of this century and particularly the 1920s and 30s. It is a story of hardship and poverty borne with fortitude, of comradeship and humour and it is told by Foresters who lived during those years. By men who as boys crawled and struggled on their hands and knees to drag coal in the pits, by those who worked at the coal face. By women who remember when men came home black from the pit when there were no pit head baths and the copper, the dolly and tub were in constant use. In short, it is a record of a way of life now gone forever, at a time when the Forest of Dean was a country between England and Wales. A true story straight from the mouths of Foresters.

It is a slice of social history captured just in the nick of time. Already some of the narrators are no longer with us, the number of men with blue scars on their faces diminishes yearly, all too soon no-one will remember the toil and danger in the deep mines of the Forest,

the comradeship and the hardships. Never again will there be such sturdy, independent men and women as those days bred and the Forest will be a poorer place without them.

Those who expect a lot of Forest dialect will be disappointed, surprisingly dialect did not figure in this speech a great deal. Perhaps this is an indication that even these true Foresters have been influenced by outside forces more than they'd care to admit, or again they may have restrained themselves purposely. But it was the voice, as much as the words, that made the speech of the Forester so distinctive. This, even more than the words, is difficult to transmit to paper and all too often when dialect is attempted in writing it makes for difficult reading. Some of the speech has been slightly modified but most of it is verbatim. The directness and vivid descriptions of these Foresters, most of whom left school at fourteen, could teach many an academic a lesson in communication. And just a few of them occasionally use a phrase which verges on poetry.

Some of these interviews were tape-recorded, but for many of them I took notes during the interview, a method often preferred by both interviewee and interviewer. Often the first response was, 'I don't know as I've much to tell you', but after ten minutes chat, memories would come quicker than I could write them down.

The book is arranged into chapters according to subject matter, more or less, few subjects remaining confined to any particular chapter. One speaker reinforces what another has said or very occasionally gives a different version or viewpoint. Accounts of schoolmasters

varied, some were exemplary teachers, some were virtual tyrants. Almost everyone mentioned home-baked bread and home-cured bacon - 'the pig on the wall'. Mining was the dominant influence and it therefore occupies considerable space in this book. Over fifty per cent of adult males in the Forest were employed in mining, in the Cinderford area eighty-four per cent. Yet, little evidence of the deep mines remains, only one engine house is still standing, almost all the above ground workings have been obliterated and only a few big slag heaps remain. Some of the heaps have been levelled, others have become overgrown and one has been 'prettified'.

The Nonconformist chapels were another dominant influence - one has only to read some of these memories to realise what a large part they played in Foresters' lives. Every village had at least one chapel and every chapel Sunday School had its annual 'treat' which are remembered with pleasure and affection.

It was the custom for young people to congregate after chapel on Sunday evenings and walk in groups of the same sex up and down a particular stretch of road. In West Dean it was called 'Monks Parade' and in Cinderford 'Monkeys Parade'. Probably it was the custom in mining districts. George Ewart Evans, in his autobiography, 'The Strength of the Hills', has described an identical parade in Glamorgan, with groups of boys and groups of girls walking up and down and passing one another until boys and girls 'clicked'. But as he said, it was all very innocent, the influence of the home and the chapel was too strong for any deep sexual involvement.

Strikes in the 1920s increased Forest hardships. In addition to the national mining strikes in 1921 and 1926 there had been a local strike in 1924. At the beginning of the 1926 strike A.J. Cook, general secretary of the Miners' Association of Great Britain, said, 'The miners have been locked out, denied the right of a living wage'. The Forest Miners' Union, due to the previous strike, was in debt and had no funds and could not give its members strike pay. Russian miners sent British miners £260,000 of which Forest miners received £1,500. However, this and what savings the miners had were soon gone, and they were forced to borrow if they could, rely upon the goodwill of shopkeepers, accept what charity there might be or apply for poor law assistance.

In East Dean the Poor Law was administered by the Westbury Board of Guardians who initially made an allowance for wives and children but nothing for the miner. Then early in August the Guardians stopped this relief. A fortnight later four hundred and fifty men, women and children assembled at Westbury. Women and children were given bread and cheese, while the men looked on, then they were also given bread and cheese. At a later date there were animated scenes in Cinderford and about three hundred women and children went to the Westbury Workhouse and demanded admittance, most of whom remained there for twenty-four hours. Other parts of the Forest were included in either the Monmouth or Ross Union and fared a little better.

By mid-August many mining families were destitute and some of the men were returning to work and had to be escorted by police. But there was no wavering whatever at some collieries - none was working at the Flour Mill, Park Gutter,

Parkend Deep, Cannop, and Crump Meadow. In September A.J. Cook came to the Forest to reinforce the miners' resolution and on a Sunday afternoon spoke to a crowd of over three thousand at Speech House. But a fortnight later four thousand men were either back at work or had signed on. On the last Thursday in November the strike was officially abandoned in the Forest and over five thousand men signed on but only four and a half thousand got work. Before the strike there were six and a half thousand colliery workers.

Today, with all the deep mines closed, the hardships that were the common lot are no longer prevalent, with many chapels closed and the rest sparsely attended the Forest is a different place. Despite the arduous and dangerous work, nine out of ten of the old colliers say that if they had their time over again, they'd go down the pit. And they all give the same reason - comradeship. Comradeship permeated a whole district. Time and again I was told, 'We had good neighbours, we all helped one another'. This warm glow of comradeship suffused their lives, enabling them to withstand their adversity.

In more senses than one this compilation of Foresters' memories can be regarded as notes from another country. Gathering them has enabled me to make new friends as well as visiting old friends and to experience that warmth which only Foresters can give. To all of them I tender my gratitude, my respect and admiration.

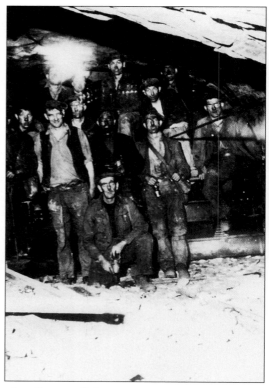

'Goodbye to all that.'

PICTURE CREDITS

A. Edwards, C. Elsmore, F. Few, M. Filby, Mary Griffiths, M. Gwilliam, S. Harris, K. Howells, M. Lambert, A. Lewis, K. Meek, E. Olivey, A. Pope, S. Reid, G. Roberts, H. Roberts, A. Wright.

CHAPTER I

Family and home

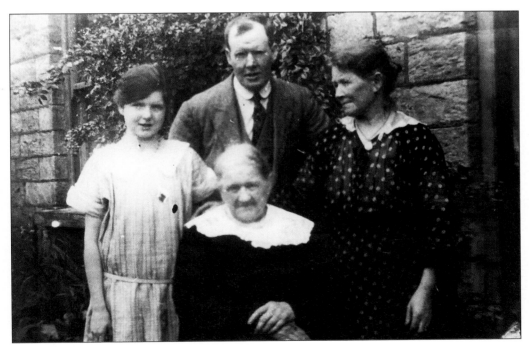

Four generations of the Butt Family.

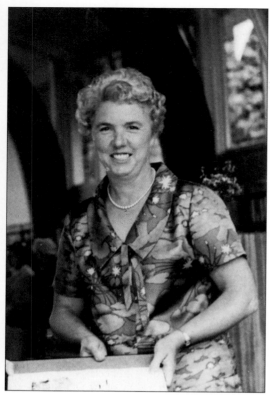

Elsie Olivey.

Large Families

There wasn't a porch, so all the draught blew in through the door, but there was a settle inside. Grandma Gibbs chair was all wickerwork. There was a front room, but if we dared breathe inside there, a shout would say, 'Come out!'. Grandmother, who was a midwife, had fourteen children. It was all stone stairs at Grandma's and where I lived.

Yes, the front room - there was a beautiful hearth rug, not a rag rug, and an organ. Our Oliver played the organ and they sang hymns. If they sang, 'Lead, Kindly Light', I burst into tears. This front room was only used on Sundays, Christmas Days and special occasions.

Tom Gibbs

There were ten of us children, all born in that house on the corner [at Abenhall], most families had eight to ten children. A woman over at Ruardean Woodside had thirteen. Her did do washin' every day - got the dolly, look, and wooden tub, every day her did wash for 'em.

John Gwynne Griffiths

Grandparents

My grandfather bought a row of five little cottages on Bilson Green at the beginning of the century for the reputed sum of £250. The top two cottages were empty and he knocked a hole through downstairs between them. When you went to bed in the top cottage, you had to go out through the door in

the bottom back, back through the door of the top one and up a stone staircase.

In the garden there were three privies and two washhouses - one of each for grandfather's family, the others shared between his three tenants. The door of each privy faced away from the cottages; each had two holes, one seated at normal height, and the other, smaller one built up higher. There were gaps at the tops and bottoms of the doors. At Bilson the privies were always emptied on Good Fridays - bucketed out and tipped into trenches dug in the garden. The inside was always kept whitewashed and abounded in 'creepy-crawlies', the outside covered in ivy. The privy at St Whites Farm (where other members of my family lived) also had two holes, one at normal height and a low one for small children. It stood on the top of the hill and the contents just oozed out and went down the bank - the poultry loved it. Once a week newspaper was burnt in the hole and then lime was thrown in.

The men washed at the kitchen sink; the women in their bedrooms - a jug of cold water and a bowl. After use the water was used to swill chamber pots (kept under the bed), this and the chamber slops went into a bucket and was then tipped onto the garden. In winter bathing took place in a tin bath in front of the fire; in summer in the dolly tub in the wash house. The dolly tub was made from a cask sawn in two, you could sink in right up to your neck. I can recall my mother washing father's back.

My father wore braces and a belt, he always said he'd catch a cold if he left off his belt. Oh, yes, it was quite normal for miners of my grandfather's generation to strap their children with their belts.

In the top house, Grandma had two rooms downstairs. The kitchen with a black-leaded range, chairs round a scrubbed table, a little shallow stone sink and a sofa - this was also their living room. The front room was also a store room, with a couple of cupboards, a marble-topped washstand which housed dripping, lard and milk. Apples, potatoes and onions were kept in that room.

Because the ground sloped, you went down two steps into the next room, (part of the second cottage). What would once have been the kitchen had become the sitting room with an overmantle and table with a polished top. And always a geranium in the window - when Grandma twitched the curtain to see what the neighbours were doing, she could always hide behind the geranium. There was a jar of 'bees wine' - some kind of yeast fed with sugar and water. On Sundays, when we went to visit her, Grandma poured out a drop and gave us it to drink. The lump of yeast floated round in the top of the jar - it was fascinating to watch.

There were no pens or ink in the house, Grandfather used an indelible pencil, always a stub, which he first wetted on the tip of his tongue before using it. Grandfather, who was a Christadelphian was fond of texts which he had hanging in this room as well as a picture of Highland cattle. But the family rarely used this room which I called 'the holy of holies'.

Elsie Olivey

The Gwilliam family.

Hard Times

Times were hard, but all families were on a par. The top priorities were food and to pay the rent in order to keep a roof over our heads. Father used to say, 'My boy, t'aint what you do want, 'tis what you can do without.' 'Twas three days at the pit and three days on the dole. There weren't any dole if you worked more and Eastern worked four days and knocked men out of dole money.'

Eric Warren

There were ten of us children and my mother died when I was three years old. I could never remember anyone cuddling or to care for me. A sister went into service in Gloucester but she came home when she was fourteen and a half to look after the family. Everybody was poor, Charlie Mason told me his mother had to toast bread black to make tea. An old lady was crying and Father said, 'Take no notice of her tears, they do come too close to her bladder.

Gilbert Roberts

There was no water at Sling, during a drought, water had to be carried in buckets on a yoke on the shoulders from a spring at Marsh Hill, half-a-mile away. Food, we had 'a good cook' on Sundays, but only on Sundays.

Mrs Goddard

The Cottage

As children we always hated meat because of pig-killing. We much preferred bread, butter, cheese. We always had plenty of eggs, but nothing fancy. We had a couple of rag mats on the stone floor, or a thick sack bag the pig meal had come in. Mum used to scrub that floor until it was white. We usually had a good fire because dad worked in the pit and us kids used to get in plenty of firewood.

My real father died when I was only seventeen months old but my mother re-married three years later and I always called my stepfather Dad.

Our cottage was near a quarry; the cottage was semi-detached, two up and two down, the back kitchen was used for storing pots and pans and the pig bench. There was a huge salting stone on which Mother kept pails and earthenware pans full of drinking water. The water had to be fetched from a spring in a little wood, usually by me. It really wasn't very far, but it took me ages.

Dorothy Foley

It was a small cottage, next to the Globe public house. A small room over the cellar of the Globe, a stairs up to a small room on the left - mother's and father's - a very small room which was the kitchen - living and eating.

Altogether there would have been nine of us children, but little Harold died from acute laryngitis - so there were left four boys and four girls. The girls did sleep in one bed and the boys in another bed and the room was partitioned off by a blanket.

The kitchen had floor boards - we could hear the barrels being rolled in and the tapping and that underneath. Oil cloth was put on the floor, people hadn't money for big carpets. They'd have coconut matting and rag rugs made out of old bits of cloth and rags with a pricker. They'd pattern them and when they got dirty they'd take them out and bang them on the line.

We always had good neighbours, all of them were relations in Globe Row. There was one communal back-kitchen used by all three households, because we were all relations they all used the back to do their washing. The big tub was a barrel cut down. When we came home from work in the mines, Mother and them would have the water hot in the furnace where they used to boil their washing.

It would be nice and warm and they'd put sacking up to the windows so nobody could look in. Where we came into the house there was a shed and we'd take our dirty pit clothes off in there and then go through the back-kitchen to have our baths.

Jesse Hodges

Clothes Washing

We had no water supply at Poolway other than rainwater which was caught in large tubs, we used this for washing. We fetched drinking water from a neighbour's spring well. In the summer we often had to carry water from half-a-mile away. And washing day was a really hard day. Everything was boiled, mother had a dolly and a tub. Firstly the clothes was dollied in the tub, then put in a bath and well rubbed, then swilled before being put in the boiler. When it came out of the boiler it had to be swilled and

blued. Then we had a very large wooden roller mangle, it was quite hard to turn the handle at times, but mother thought it was a gem.

For ironing you had to get a nice red fire, mother had a number of flat irons which were put in front of the fire. You had to be sure and wipe them well before use in case there was any soot on them which would mark the clothes.

When times were hard mother took in washing. She even did stiff collars and had an oval iron for polishing them - she used a kind of wax. And grocers' long white coats, after washing they had to be starched.

We never had luxuries, but we were well fed, plenty of vegetables, a little meat. Mother knew how to make the most of the least.

Doris Harvey

The Privy

We had an earth closet, reached from the back-kitchen and father used to clean it out from the back. He kept it sweet by using a lot of lime. At Poolway it wasn't actually in the garden, it was all under shelter. In Coleford a Mr Smith used to go round the houses once a week to empty the privy buckets, the contents being tipped into a cart. It was a queer shaped cart with a lid. I always gave it plenty of room, the smell was terrific, it was terrible. I often wondered how he disposed of its contents. The smell was really horrible, our earth closet at Poolway was much better.

Doris Harvey

At Flaxley the privy was a self-flushing effort as it was built over the stream. Then we moved to Cockshutt and we moved up in the world because there was a three-seater. In the winter at least five of us went down together with a candle in a jam jar. We never had a wardrobe, there was a clothes closet. Nothing on the floor except some old rugs, sheep rugs and rag rugs. That was Mother's pastime, making rag rugs.

Arthur Holder

Washing

There were no pit baths then. We had a big boiler in the back-kitchen and it was put on ready for my father and three brothers when they came home from the pit. On clothes wash day the boiler fire was put on first thing in the morning. In the back-kitchen we had two dolly tubs and a mangle, a rubbing board and a big bath. When Eastern United started its pumping drained all the wells and then a mains water supply came to Ruspidge.

We always washed with rain water, there was a big tub outside the back door to catch rain water. In the morning Mother used to take a bowl and wash out there. 'There's nothing like rainwater for your face,' she'd say. We had a stone sink, that's where we had to wash. The boys had a bath out there, in front of the big range. The boiler was on every day practically.

Amy Howells

The old furnace, the old copper was on all the time.

Eric Warren

We had a bath in the dolly tub out in the back-kitchen; there was a furnace of boiling water there, bath tub in the middle and a rough old towel - a piece of sacking, washed and ironed and hung on the beam. Oh yes, you'd just clean your pit clothes off. [trousers] We never washed them, eventually they were cast off and you'd get another pair.

Alfred Warren

Yes, I know about the miner's life - dirty old pit trousers. My father bathed in front of the fire, oh yes! Him wouldn't let you see him bath - no, they'd got their pride - oh Lord ay!

Washing day? It was hard work! Oh dear, dear oh! First washing I'd done after I was married, I had to rub everything, there was no dolly or dolly tub, 'cos we hadn't got one as we hadn't been married long enough to get one of them. I'd get a bath in front of the fire, if you please, in the old back-kitchen and that's how I had to do my washing. Then a neighbour round the back said, 'You let that alone, I'll come and help you do that. I'll be round.' By the time her'd got round I'd got the washing done. Well, I didn't like for her to come and do it.

You didn't have much furniture in them days - I had half-a-dozen chairs. They were two and elevenpence each. Oh yes, I had an armchair and the chairs and a table and a sofa, after we'd got things together, and that's all we had. We hadn't got the money to do otherwise. My husband was earning 'bout five and

Mrs Howells.

sixpence a day, there was the stamp and all kept out of that, look.

Amy Adams

CHAPTER 2

Schooldays

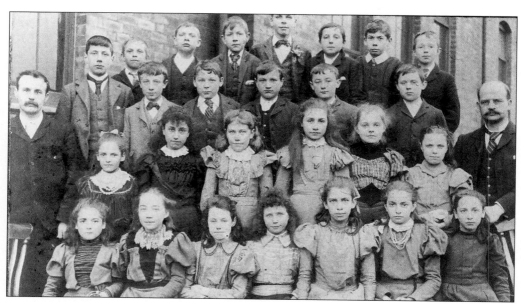

A class from Double View School. Headmaster J. Emery is on the right. 'The great terror was Mr Emery.'

'Schooling was strict'

My father went to Drybrook school and to Steam Mills school. The schoolmaster rode a donkey to school, he lived in Drybrook, but he rode the donkey to school - my father told me.

When I went to school, if you truanted there was a school 'bobby' to see if you were genuinely ill. If you were he wouldn't bother you but you had to have a doctor's note and that had to be sent to school. If you weren't ill and you weren't at home, he'd go out looking for you. If he found you he'd soon have you back at school, because he'd get you by the ear and drag you back.

Schooling was strict. You learnt because you had to learn and that you wanted to learn. Because you had to look forward to something better than your forbears had - something better than your father had. My father was right against his sons going down the mine if he could possibly help it.

It wasn't only the conditions that kept us all down, we were held down by the 'upper crust'. There was definitely a dividing line, there was those who had and those who hadn't.

Jesse Hodges

When I was five I went to St John's Infant School (Coleford) and at seven you were transferred to St John's Girl School. There were six standards [classes]. I should have liked to have sat for the scholarship for the Grammar School but my parents couldn't afford to allow me to continue with my schooling so I left at thirteen and a half.

At St John's there were two classes in each room. We sat on backless benches.

Doris Harvey.

The vicar - we called him 'Daddy Brice' - used to come and teach us scripture. Apart from that we were only taught 'the three R's', but in the last year we were also taught botany and I learned to know the names of all the wild flowers.

Doris Harvey

17

Gunn's Mills in 1995.

I went to St White's School, Mr Woodman was the headmaster and his wife taught needlework. There were two classes in each room. In the babies we had slates and later pencils and copy books. We did a lot of copy writing. We'd write a line and copy it several times over.

Then we went 'down around'. Yes, there was a 'down around', that was standards one, two and three. After that it was Double View [school]. I wasn't at Double View for very long. Mother didn't like the idea of me going to Double View, Emery was the headmaster then. So I went to the Grammar School, Mother had to pay for me to go there, I think it was seven and sixpence a quarter. It hadn't long opened then, there were only about sixty or seventy pupils.

Amy Howells

When we lived at Flaxley, we used to go up to Gunns Mills and play with the Ryder boys. We used to play all over Gunns Mills, a great rambling old building. Then I started school at Plump Hill and we had to walk all up the fields, up to the tops of our boots in mud.

Oh yes, we always took our dinner, in a little bag - a tommy bag - with a tape on, just like the miner's bags. I wasn't at the Plump long because Father moved to Cockshoot Farm [between Littledean and Newnham]. We then went to Littledean School. It was a bit grim; there was an infant place at the back but there were five classes in 'the big hall', as we called it. We all sat on backless forms and all dirty because everyone came in hob-nails and dirty, mucky old shoes and it was filthy and the teacher stood in front and did the best she could in the

18

circumstances. The place was stone cold in winter.

Cullis was the master and what he lacked in size he made up in viciousness. He had a lad named Reggie King living with him and there wasn't a day that he didn't thrash that boy - and I say thrash, I mean thrash. The toilets there - the boys just went against the wall and I expect if you wanted to go number twos you went in a bucket and that stunk to high heaven. What the girls' was like I don't know, I suppose they must have used their buckets too. Yes, and just below the school there was a big, high wall and behind this wall was the cess pool from the village. And we used to sit on this wall and eat our dinners.

School equipment was very poor, there were slates and slate pencils, perhaps we may have had pencils and paper later, but I don't remember them. It was a big day in the winter if it was very bad weather because all the children from the Bailey and Pope's Hill were allowed to go home at 3.45 p.m. It was a big day if we got out at a quarter-to-four.

We had fun going home. We walked on top of all the walls. One day you were in with the Smiths and the next day you were in with the Baghursts. And 'you're not going to play with our ball,' and all that business. But we got on and had good fun. There were two walnut trees at Cockshoot and every year they were loaded with walnuts and we weren't supposed to touch them. But we used to fill our pockets to go to school and for a time we were the most popular kids in the school.

Arthur Holder

Arthur Holder.

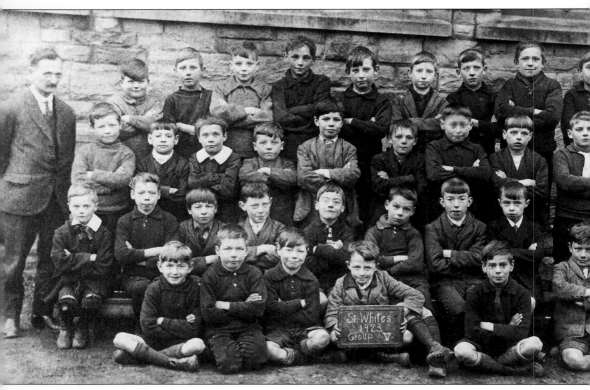

Group V of St White's School, 1923.

I went to school at St White's [Ruspidge], first the infants ruled by Mrs Marfell, then by Mrs Cooksey who was a wonderfully kind and understanding head teacher. Next the big school ruled by Mr Woodman and a very kindly man. It was a long walk to school from Pembroke Street. In summer we went along the Meend Gardens. In the winter we went along Church Road. Perhaps the joy of winter time was hurrying out of school and getting on to Church Road as quick as we could, in time to see the lamplighter coming along with his pole and lighting lamp after lamp. And then, up from the Green as we got nearer to home, were coming the miners from Crump Meadow and Foxes Bridge Collieries, and they were hardly distinguishable, in those days, with the coal dirt on them. They would go to work in the dark in the mornings and come home in the dark at night. They didn't see daylight. There was always a cheery word from those who knew us and we were never afraid of a collier.

I left St White's for Double View when I was nine. At Double View there was a different kind of headmaster altogether, one who a lot of people feared. Yet, I always found him just in his dealings with me. This was Mr Emery, he was very strict.

Frances Webb

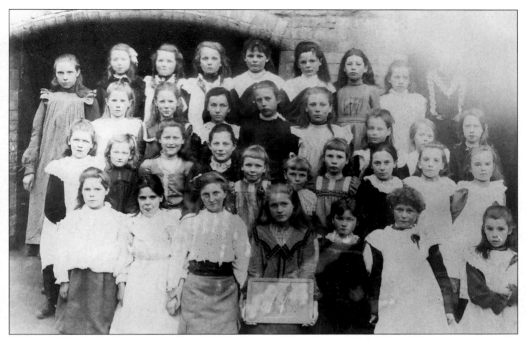

Pillowell School, *c.* 1908. Annie James (Lewis) is in the centre holding the slate.

I was born on Ruardean Hill, Rudin' Hill. All around there is truly Forest, yes, 'tis true Forest. My mother had twelve of us, but some died in infancy. Father was a miner. Remember Father? Oh, Lord alive! Made a fool of me. I was the only girl among all them boys, mind.

I went to school at Steam Mills. I walked there and later I walked to Double View. Twelve months at Double View - you had to pass an exam - Double View for a year. Mr Emery was headmaster there, he was strict, well, he'd got to be with all those children. He wasn't frightened of us, mind.

Amy Adams

As I say, that pond [at Soudley], we knew every inch of that down there. We used to go out and see it as we went off to school to see if it was hard enough, (in the winter after hard frosts) to slide down there. We used to see the old school bus and we used to hear the school bell go and we never took no notice. And we used to slide right across where the main brook went down, we did go right across to there. Sometimes we did go right through the ice and we've been up to our knees in mud and we did get out and walk through the wood and walk through the brook to wash the mud off our stockings and shoes and gone and sat all day in it at school.

And the old school boss, Alec Hull, would come out on to the Soudley Camp, as 'twas then, and allus look and blow his whistle and beckon us and of course we was late. We did go on then and him

21

did meet us in the porch with the cane in his hand. 'Come on, Master Drew, hold your hand out,' he did say, and it was a swipe. 'Come on, Master Merritt . . .'

Alan Drew

I got a job as lather boy with Barber Hawkins in Church Street [Cinderford] while I was still at school. I worked every evening, except Thursdays and Sundays, from 5 p.m. to 8 p.m. On Saturdays I worked from 8 a.m. to 9 or 10 p.m. I was paid four shillings a week which paid our rent. A shave in those days cost tuppence and a haircut sixpence. And while I was still at school, it was in 1927, Frank Stephens from Westbury started a milk round in Cinderford, he had a bull-nosed Morris van and milk was thruppence a quart. I used to help him on Sunday mornings to deliver the milk - buckets and ladles we had - and was paid two shillings.

A.F. Ensor

Near Huntley. Three of us boys played truant one day to follow the hounds. Next morning the headmaster gave us fifteen strokes of the cane on each hand. Then he walloped our behinds and kept us in every playtime for a month. Thirty years later he sent a message to me, would I bring him a basket of cherries from the orchard. Well, I sorted out the very best cherries and took them to him. I reminded him of what he'd done when I was at school, he said he couldn't remember that but he did, y' know. I reckon those lovely cherries made him think.

A.J. Watkins

A woman brought a child, about to start school, in a pushchair to my mother, to beg for a pair of shoes for the child to wear to school.

E. Ball

There were ten children and my mother died when I was five. We lived at Newham Bottom and I went to Ruardean Church of England School at first because that was where my older brothers and sisters went. We had to walk over three fields and get over three stone stiles I remember. Yes, and I can remember the Relief of Mafeking, all the chaps around went wild . . .
Mr High was headmaster at Ruardean School. Caning? Why he was a-caning all the time. And Mrs High, she was very cruel. So I left and went to the school at Slad. Mr Burton was the headmaster - they were very kind at Slad.

Amy Hale

I went to Christchurch School, I hated bloody holidays. Why? Because I had to take sheep every day to graze, down at Whittington Brook and stop and watch 'em all day. When I was twelve, during the summer, I had to fill hogshuts with water from Quabbs Pool - two in the morning and two at night for Smith's dipple and Redding Horn and Shadrach Hughes's pit opposite the Rock pub. I wasn't tall enough to reach the top of the hogshut and had to stand on a box. The hogshut was a tub on two wheels drawn by a horse. The water was for raising steam at the dipple and the pit. I used to pray for a good thunderstorm, because then I didn't have to go as they caught the rain off their sheds. I was paid

Harvey Gwilliam.

Len Russell.

half-a-crown a hogshut, but Father had the money. I don't complain about that, Father was good to me. Yes, I left school when I was fourteen.

Harvey Gwilliam

Before I went off to Westbury school in the morning I had to feed and clean out pigs, and the smell of pigs hung on my clothes so that nobody liked sitting by me. There were several children from the workhouse just up the street from the school and during the break a tiny man, not quite right in the head and an inmate of the workhouse used to bring a basket of buns for the kids.

Some of 'em was bigger than him with the basket and all on 'em was pretty ravenous. Oh, they used to rush at him to get them buns, knocking him this way and that, they didn't half give the little fella a time on't, a fair tousling he had. 'Twas a wonder he kept a coming every morning but I s'pose them up there made him.

Sydney Cripps

Cyril Elsmore.

Mr Joe Pope was headmaster at Ellwood when I went to school. He was the finest headmaster anyone could have. He thought sport was everything, football, hockey, everyone had to play. He used to say, 'Play the game and people will play the game with you'.

One time the school had no money to buy a football, so Mr Pope sent two boys with a note asking Coleford traders for money to help buy a football. We used to play all schools in the area, Steam Mills, Redbrook, Lydney . . .

Mr Pope bought a Morgan three wheel car, but Mrs Pope was a well-built woman and when she got in the car tilted over a fair bit. He took the forwards to matches in or on the car, wherever they could perch. 'Musn't have you forwards tired for the match,' he'd say.
We had some real good fun with that Morgan and with the football.

Then Mr Pope started a school garden. With spades, rakes and hoes on our shoulders we marched to the garden. We could take produce home, but first we had to lay it out for inspection. 'Do you want all that? Because Mrs Brown hasn't a big garden and her husband's ill,' was one of his many comments. Oh, we took produce to Sling, Parkend, to Broadwell, Clearwell . . .

During the strike in 1926 practically everyone in Ellwood was out of work. In lots of families there were six, seven or eight kids and not much to eat. Mr Pope got a number of women together, took over the Ellwood Sunday School building and organised a meal service for the children.

The first job for the boys was to go and get wood to light the fire. Then coal

School? It was up on the blackboard, your tables and all, and the stick on your legs.

All the boys wore jerseys, short trousers and hob-nailed boots. Wind-chapped legs and scabs on the knees where they'd fallen down. The girls wore pinafores - the better off wore stockings.

Len Russell

If there was no cane handy, the assistant master at Drybrook School would order a boy to go and cut a stick from the wood. When the boy came back he'd cane him and say, 'Hard is the life of the transgressor'.

Stewart Harris

24

was needed, well, there was the old tip of a closed pit right opposite Ellwood School and both boys and girls were sent to pick coal from the tip. Mr Pope had a strict rule about this, the boys had to go to the top of the tip to find coal, the girls had to stay at the bottom - he wasn't going to give the boys the opportunity of looking up the girls' frocks.

The pupils were to bring any vegetables from home that could be spared. John Jordan, a grocer near Milkwall got a grant from the parish and brought groceries in a wheelbarrow. At that time there were a lot of rabbits around the quarries but after some months there weren't any. We learnt to catch those rabbits, we got really good at it. We took rabbits to school and home.

To regulate the flow of vegetables and so on, Mr Pope issued three tickets - made from exercise books - a white one for potatoes, green for vegetables and red for any meat available which would be for Wednesdays only. There was also bread with lard or dripping and, if you were lucky, a sprinkling of brown sugar.

Cyril Elsmore

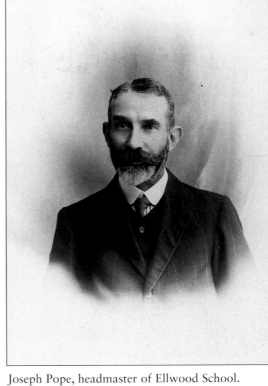

Joseph Pope, headmaster of Ellwood School.

Annie Lewis.

its like this, some of us just had to be privates.' . . . He got the job.

The senior French teacher at Lydney Grammar School used to say to any pupil who was a little behind in the subject, 'You lad, could have done with another half hour's baking.'

Like most schools, Newnham had a school garden - a large one, each pupil had his own plot and grew vegetables. It was an excellent thing, something really useful. Woodwork was another skill that was taught. I have gained more from Oxford School Certificate in woodwork than - say chemistry or physics. But I am sure it would be looked down on today. Which makes me ask the question, what is education for?

John Billings

My grandmother (born in 1876) and my mother (1905) were taught at Bream School until they were thirteen or fourteen. In those days, I suppose, there was very little equipment except slate boards and chalk, but I never considered them to be anything but adequately educated and not only in English and Maths.

My father, (a headmaster himself) used to tell the story of a headmaster in the Forest who was looking for a caretaker/odd job man. One man interviewed was an old soldier. 'I see you spent twenty-five years in the Army.' 'Yes, Sir, that is correct.' 'How, after twenty-five years service were you still a private?' The old soldier thought, he looked at the floor, then he looked at the ceiling. 'Well, Sir,

The fare (on Meek's bus) from Ruardean to Cinderford was fourpence adult and twopence a child. From the Morse Road, where I lived, it was threepence and three half-pence, unless you walked two hundred yards down to the little chapel where it became twopence or one penny. Many a halfpenny thus saved on the way to school became five caramels from Mrs Smith's shop.

The morning and evening schedules were arranged to fit our Grammar School day. Two buses ran in the morning from Ruardean and from Woodside. The routes came together at the Morse Cross.

In the late thirties the Woodside bus was an oasis of serenity, order and good manners. After a polite, 'Good Morning' all round on entering, the rest of the journey would be spent in polite conversation.

It was different on the Ruardean

bus. As the bus pulled up and the door opened, new arrivals were greeted with a hail of missiles and personal abuse. Paper pellets projected by rubber bands, somebody else's cap, peas from a peashooter, a variety of missiles shot through the air, the fusilade accompanied by choice epithets directed at one's real or imagined personal inadequacies. It was as well, before entering, to remove the cap to a safe pocket, button the jacket tightly, tuck the tie safely away and grasp the satchel grimly to the body. For it was war, no quarter asked or given, at least until the next stop, when one could gain relief by joining in the assault on the next victims.

No one was safe, boys sat on girls laps, sometimes girls on boys. Interesting questions were asked of the girls, (but never answered) scurrilous statements made about the boys, all at full voice. Pins were stuck in, hair pulled, property abstracted and passed from hand to hand, scuffles broke out and boys leapt up and down the gangway on nefarious errands. Sober citizens at the roadside were surprised by a volley of catcalls and personal comments from windows as the bus drove past.

The general public soon learnt to be wary and morning and evening avoided the bus like the plague. On Thursdays, however, early closing day, they had no choice, for ours was the only bus at that time of day. Let somebody show a peculiarity and he was lost. Respect was there none, for people or conventions.

Geoff Lardner

The great terror was Mr Emery [Headmaster, Double View School]. Mr Emery knew everybody was too poor to buy anything else but a cap and they were one and sixpence ha'penny at Mr Jacobs shop. One of the boys who'd been there longer than me - I'd only just got to Double View - gave us a bit of information. 'When old Emery has got a bit of spit on his lower lip, keep out of his way, he goes mad with his stick. I never saw him without his stick.

Every Monday morning you had to sit on the floor cross-legged. Two groups of boys with a gangway in between (the girls stood at the back). Mr Emery would appear with piercing eyes and his cane. And as he came along - 'Ah, you did bad writing!' Whack, whack, whack! Three across the neck and shoulders. He terrified me.

There were five boys, two a bit backward, one mentally retarded. He used to ridicule them. On Monday mornings he used to beat them just as a matter of form. Emery was feared, Mrs Emery was nearly as bad.

Harry Roberts

My dad was a collier. When he was a boy his schoolmaster said he had a good brain and it would be a shame for him to go into the pit, but there was nothing else for him.

Annie Lewis

Grandad Ben Marfell was born in 1837 - in a poor home at Ruardean - and he started work when he was about nine years old. His job was minding the door at the bottom of the old Slade coal mine.

Kate Meredith

CHAPTER 3

Chapel

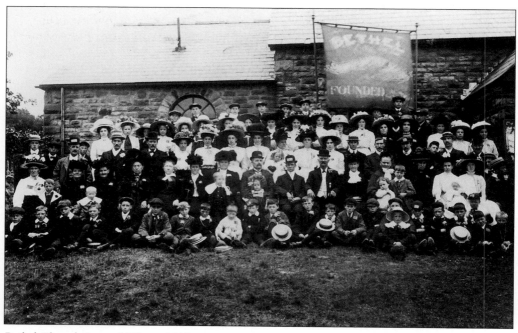

Bethel Chapel, Steam Mills, *c*. 1910.

Everyone to chapel

Chapel was a must; Sunday school in the afternoon, chapel at night. The Primitive Methodist in Church Road (Cinderford) was our chapel. The chapel organised outings - the first time I saw the sea was on a chapel outing to Barry. The Sunday School had treats - we were given half-a-day off school - sports in the field. Mrs Beddis made ice cream and ginger pop.

A.F. Ensor

Grandfather was a preacher and he'd walk from Drybrook to Woolaston, Lydney, Yorkley and other places to preach at the chapels. Sometimes several preachers would meet at the Speech House and walk back together.

Up to the age of sixteen we went to the Methodist chapel in Drybrook three times on Sundays. When we were older it was twice. At the evening service our chapel would be full, about a hundred and fifty people there'd be.

M. and S. Harris

The colliers, their wives and childred, all went to chapel, We went to the little Baptist chapel at Green Bottom. It would be full, afternoons and evenings.

Eric Warren

We had two Methodist chapels in Ruspidge, counting the one at Cinderford Bridge. The one down in Ruspidge was originally Bible Christian. It was the hub of the village. Everything was held there; teas, concerts, magic lantern shows, temperance meetings, political meetings. It was the only place where people could gather really. Ever such a big Sunday school, bible classes, including a well attended one for young men. That was until the First World War.

The chapel was a way of meeting people, y'see, and the Sunday School Anniversary was the highlight of the year. That was when I had a new frock. Big choirs, special hymn books, singing and recitations. Two ministers from Bream, Mr Ball and Mr Batt always came. Yes, that were their real names.

We didn't have a permanent minister, local men would preach. The Sunday services were well attended but some of them came to sleep. We had a half-day holiday for the Sunday school treat. Bible class men carried the banner and we had a band, usually the Two Bridges Band and the band paraded from the chapel to the White Hart and back. We had bread and butter and cake - nothing fancy - seed cake in bags and taken round in a clothes basket. We took our own cups, slung round our necks on a piece of tape. There was home made pop, and games and scrambles for nuts and things.

Amy Howells

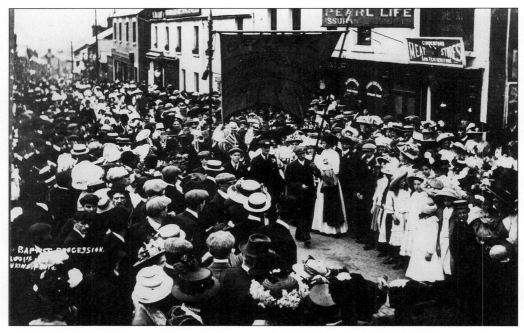

Bethel Chapel marching through Cinderford on Treat Day. 'Here comes Stim Mills!'

I started going to the Wesleyan Sunday school when I was about four years old. The primary Sunday school was held in the present Guild Room. The little wooden chairs, the picture of Jesus with children from all lands on his knee and the Cradle Rolls. There was Miss Maud Morgan, a kindly and gentle lady, sitting at the piano as we sang with great gusto, 'A sunbeam, A sunbeam, I'll be a sunbeam for him.'

My mother had also attended Wesley Sunday school and been ruled by a fierce little Miss Kear. Father had attended Wesley. Since he was already working at Crump Meadow Pit he would have attended Wesley because if you worked at Joseph Hale's pits you went to Wesley - if you knew what was good for you. If any of Hale's men were not in their accustomed place in chapel on a Sunday, Joseph Hale would want to know the

reason why. If you wanted to get or keep a job you attended the chapel of the pit owner's choice.

George Kear superintended the Sunday School and fostered in us a love of music. We learned the Tonic Sol Fa and words were memorised. George Kear would never allow hymn books or music if we were appearing at Anniversaries or other occasions.

With enthusiasm we sang, 'Hear The Pennies Dropping' as we filed to the front and dropped our penny in the collection plate. It literally was a penny for those were the depression days of 1920s and early 1930s when many of our fathers were struggling along on pitifully small wages at the pit - or even more pitifully small dole.

Once a year we had a Prize Giving and once a year was The Treat, this was a great occasion because we were allowed

the afternoon off from school. The Wesley Treat was always on a Thursday afternoon (early closing day) and we paraded through the town wearing our Sunday best and with an enamel mug hanging round our necks on a piece of tape. With the Town Band playing and the Sunday School Banner fluttering at the head of the procession, we went up Belle Vue Road, along Littledean Hill, waving to Mum and Dad as we passed, until we reached the Causeway where the chapel owned a field. There we ran races, played on the swing-boats and roundabouts, scrambled for boiled sweets and little biscuits with icing on and tucked into a sumptuous spread of bread and butter, sticky currant buns, cakes and mugs of tea. It was always the highlight of the year.

Sunday School Anniversary was another great occasion. We girls always had a new dress, even though our mothers must have been hard to provide it. In those days it was more likely to be a made-over from one of our more obliging aunts or cousins. My favourite of all time was a white broderie anglaise with a pink satin ribbon sash. That it had once been Great Aunt Amy's petticoat did not distract in any way from my pleasure.

Elsie Olivey

We went once on Sundays to the Bethel Chapel at Steam Mills. This chapel was a branch of the Baptist chapel at Cinderford and a sister to the one at Green Bottom. There'd be sixty in the congregation at that little chapel on a Sunday.

Gilbert Roberts

My father was leader of the choir there. Mr Dee, the organist used to come out on the Tump after the service and say, 'That was a damn good sermon'. No, we never picked up a ball on Sundays, we weren't allowed to. No songs either apart from hymns.

Mrs Roberts

No, nor you never saw washing hanging out on a Sunday, oh dear no.

On August Bank Holiday we had our treat, our tea. Cinderford baptist and the two stations - Steam Mills and Green Bottom. Cinderford Excelsior or the Town Band came down to Steam Mills. And with the band playing we'd march to Cinderford. The cry would go up, 'Here comes Stim Mills!' And there'd be Green Bottom marching to meet us. We all met at the Baptist Chapel in Commercial Street.

The Sunday School would call out the different classes, one after another, coming out of chapel. There with the band playing, the banners held high, we all marched down High Street, then back up Belle Vue - the streets would be full of people - across Littledean Hill Road and into Oak Field. Oh, it was a great day! We'd march round the field until we saw the sticks with the name of our class. Yes, it was a red letter day for us! Then the teacher of the young men's class would get two scholars to go to the marquee to pick up our clothes basket of food - sandwiches, buns, sliced cake and jugs of tea - big white enamel jugs.

Then we'd have games and a firework display - oh, they were good old days.

Gilbert Roberts

31

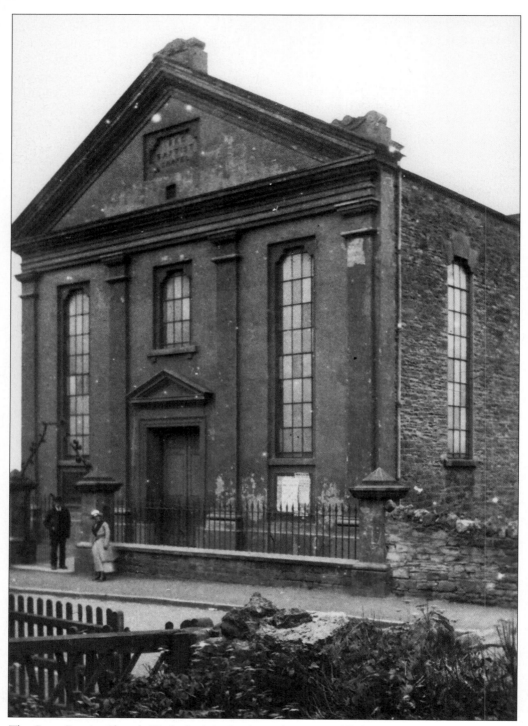

The Great Baptist Chapel, Cinderford, in the days when it was filled to capacity.

The Baptist Chapel, Cinderford, in 1996.

I went to Ruardean Hill Baptist Chapel when I was three. Mr George Williams's chapel - later I was one that helped him start the Good Templars. I'll tell you summat, I don't know the taste of drink. Oh, I can't take it, I don't know the taste of drink.

That little chapel on the Hill used to be full when I was a little girl [she was born in 1891]. I went every Sunday to Sunday school, morning and afternoon, and chapel at night. When I got older I went to the Congregational chapel at Drybrook. 'mother,' I said 'I don't like going up to the Baptist chapel when all my friends go to Drybrook.' 'Well, you don't, do ya?' My mother, her said. 'If I do let you go, you be sure you stick it.' 'Oh, yes,' I said, 'I shall stick it.' So I walked from Ruardean Hill, down through the fields to Drybrook - oh, we did enjoy it, and when I was old enough I joined the choir. We went to the I.O.G.T., the youngsters. Course there were prayer meetings and all and you got more at a prayer meeting then.

Amy Adams

Yes, I went to Sunday school at the Methodist chapel at Knights Hill. We had Sunday school outings. Once we got on the train at Drybrook station, oh, ever so early, about four in the morning I think, and went to Portsmouth to see the Fleet come in. That was a very long time ago. Oh yes, we had lovely outings and treats. At Whitsuntide we used to walk with the band from Knights Hill down to Ruardean, we stopped at the Malt Shovel for pop and biscuits, then we marched on to the Farm Tump at Ruardean Woodside where a service was held. Other chapels joined in and we also went to other chapels. We used to go to the Anniversary at Crooked End, Ruardean. And I went round singing with the choir at Christmas. But it was all a long time ago, I was born in 1892.

Amy Hale

33

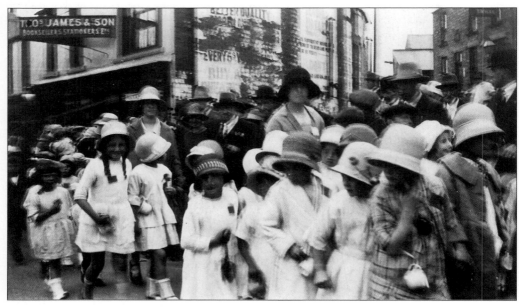

Baptist Treat Day in Cinderford. Note the mugs on strings.

Uncle George Hale was a lay preacher at Knights Hill chapel and he'd announce 'The service will begin at half-past two o'clock and the preacher for next Sunday will be nailed on the door.'

It made us children titter, but he always said it.

Joan Hale

If someone at work died - or anyone locally - everyone went to the funeral. And properly dressed too - black bowler hat, navy-blue suit, black tie. The bearers left their hats on the wall when they carried the coffin. This led to the saying 'The bowlers will be on the wall,' if anybody was doing anything a bit dangerous. That's what they said around Broadwell.

Len Russell

The rector came to school like he did, and every time he came he said, 'Who went to my Sunday school yesterday?' Up went the hands and he'd look and say 'All the rest of you are dissenters.' Well, I didn't know what a dissenter was. If our dad was a dissenter - well, he was a good man because he went to chapel.

When I was a little boy, Jimmy Pritchard used to come round with a flat float with fish. He used to shout 'Fish-alive-o!' and he used to go down along and shout, 'Fish-alive-o!' Well, we went to chapel, Father had to preach. Crooked End chapel was packed in those days. I was sitting by Mum. Father gave out the text, 'There was a lad with five loaves and two small fishes.' I jumped off the seat, my arms in the air and shouted, 'Fish-alive-o!' People laughed, but Dad didn't laugh. I had to go into Uncle Aaron's every morning for prayers, sit on the seat, I didn't bow my head, mind you,

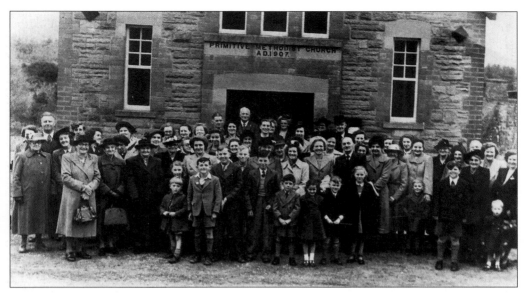

Opening of Moseley Green Chapel, after redecorating, in the late 1940s.

I peeped through my fingers. Then Uncle Aaron opened the great big bible that was on the round table and read so much out of it, then he knelt down, everybody shut their eyes. But I didn't shut mine and the cat jumped on his shoulder and when the cat was settled he then offered the morning prayer and when he said 'Amen' the cat jumped down.

Tom Gibbs
(local preacher and headmaster)

Baptist services were being held in a private house in Cinderford in 1842, the present chapel was opened in 1860 and cost £2,400 to build, but it stands on the site of a smaller chapel built in 1843. Records state that 1,200 people attended the present chapel, each paying a shilling for tea. In 1875 it was enlarged and two years later classrooms had to be added (at a cost of £600) to accommodate the growing Sunday school. By 1910 the Sunday school numbered 1,500 and had 70 teachers. One can understand why the streets were full of people and the procession was a mile long on the days of the Baptist treats.

Elsie Olivey

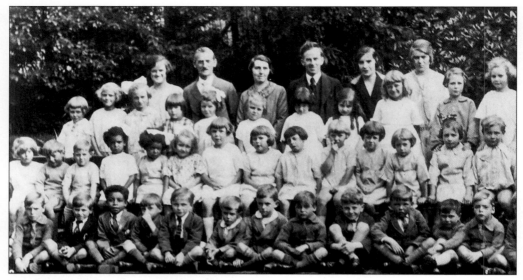

Primary Class at Wesley Sunday School, 1926.

Baptist treats - our Guild used to do a lot. Oh, dear, oh, it was a big day, mind - it was a marvellous day and we'd generally have it fine, never hardly have it wet, it was lovely. Ay, mugs tied around our necks.

When we were first married, our Baptist Chapel was absolutely filled - had to put chairs up the aisle. Oh, there'd be about fifteen hundred in there I'd think. Oh, yes, it was a big Sunday School in those days - they were all full, all those classrooms, I don't know how many, twenty-one, I think.

Oh yes, everybody came from everywhere to see the procession. [Girls in service outside the Forest used to return, if possible, for treat days]. We'd got Green Bottom and Steam Mills look, all the Sunday schools - it was lovely, mind! You don't have no teas or anything now, look, we don't. Nor no outings or anything they don't have.

Yes, I still go to chapel every Sunday - not in the morning because I don't walk up there, look, but in the evening I do go. I don't miss, if it's raining torrents I do go. Oh yes, that've bin my Sunday since I was a little girl.

Amy Adams

The Baptist chapel treat was a big event. The only time I remember going to the Baptist chapel, I was induced to go by other boys and when we got in there we went up in a sort of gallery. All the more important people were on the ground floor, the second-class citizens (and there were lots in those days), they were in the gallery. I said, 'What are we doing up here?' They said, 'Well, when they stand up and sing, this is what we do.' And they'd got little balls of paper which they threw on the bald heads. We were caught at it and thrown out, so I never went no more. But I did go to the Band of Hope. We went down the Baptist chapel lane and in through a gate there on the extended part of the building. You

had to put on a surplice. They were blue, mauve or red - I think the girls had red and the boys had mauve. You went into this place and Mrs Clough used to say, 'You can't enter this room unless you know the password. You should know the password from last week. I said 'Yes.' All the others said 'Yes'. 'It's aright - aright', and I never knew the meaning of the word aright. And you had to say that and you were allowed in.

Harry Roberts

Three times on Sundays; Sunday school in the morning and again in the afternoon, chapel service at night. We were really a crowd at Sunday school. The annual treat was a great day. We had tea at the chapel, bread and butter and special cake which was made by Butlers of Blakeney, who were supposed to be the best cake makers. Then we had to wait while Pillowell Band had tea - that always seemed such a long time to wait. However, at last the band played. 'One, Two, Three.' And off we went, marching behind the band and the banner. Two young men were chosen each year to carry the big banner. It was the only day in the year when the banner came out. Oh, it was exciting. So exciting as we marched down to Danby Lodge; the band playing, the big banner held on high, the crowd of us. At Danby Lodge we had games - and we played 'Kiss-in-the ring', the boys and girls - oh, yes, it was a great day for us, it was a great do, how we looked forward to it and how we enjoyed it.

Annie Lewis

A party of Bible Christians came to the Forest and a Bible Christian chapel was started at Crooked End, Ruardean and my grandfather was converted and became a local preacher. He walked many miles to chapels - to Ruspidge, Soudley . . . Once at Bailey Lane End he took morning and evening services and as no one had invited him to dinner, he sat in the wood all the afternoon. The next time he went there he took food in his tommy-bag which he hung on the pulpit.

When the Bible Christians started to build a chapel at Knights Hill, he was working at the New Pit near the Pludds and living at Ruardean Woodside and on his way to work every day he stopped to help with the building. He was a strict Sabbatarian - any cabbage for Sunday dinner had to be cut on Saturday, no washing-up was done on a Sunday and only the Sunday Companion or Christian Herald were allowed to be read on Sunday.

Kate Meredith

CHAPTER 4

Iron miner

Frank Joynes in the Miners Arms, Sling, 1983.

Iron mining in the Forest of Dean dates back to Roman times and perhaps beyond. It experienced several ups and downs, in the latter half of the nineteenth century it was prospering, only to decline by the turn of the century. In 1945, the New Dunn, the last iron mine in Dean closed.

Frank Joynes who was born in 1897 went to work in the Turpin Mine when he was thirteen years of age. His job was carrying a billy strapped to his back - the billy held Er cwt of iron ore. He worked eight hours a day, six days a week and was paid six shillings and sixpence a week. He then worked in Peter Jones's level which closed after he'd been there for three months. For nine months he worked with four men and eight or nine boys in a mine owned by Fred Jones. At this time he carried out fifty billy loads of ore a day.

'**R**ight outside we carried them; not far', Mr Jones said but Mr Jones's "not far" was a long way.'

By 1910 Mr Joynes was at Eastern Iron Mines, again carrying a billy:

There were seven or eight men and six or seven boys at that mine. There was a lot of iron ore there but the water beat us. At Number Three in the spring the water would go down of its own accord and rise again in the autumn - like as tho' it went with the tide. Water would drive you out from your work. Me an' Charlie Smith, up to our knees in water to come out. Terrible! Terrible! Last time we were in there we had to go to Turpin to get out. We've had some truck with that water - me an' Fred Smith and Charlie. We'd no pumps, y'see. We had to rely on the water goin' down on its own. There'd be lakes of water, then down it would go on its own. Oh, we've had some truck with that water - me an' Fred Smith and Charlie.

The iron ore could run in patches - small lots or bit lots. If it were soft we could get at it with picks only, if it were hard we had to blow. It took two men to bore a hole with a drill. The hole would be an inch and a half bore and two and a half feet long. Ah, one man held the drill over his shoulder. We'd make three or four holes. Blotch powder, which was black or red powder - a cartridge was used, then the hole was rammed with clay. Sometimes a candle was used as fuse. Then we'd get twenty yards away and after the explosion wait for the smoke to clear. Then we'd pick off the loose and clean the holes.

I've seen it like a great cave of iron, with the help of a pick you could keep shovelling. They called it the cathedral. A round mouthed shovel, a heavy pick, a sledge hammer and drills, that was our tools. The ore was very hard, 'twould fly off like flint, some was like small coal, brown or black, black was the best.

Mines? Number Four, Number Three, Number Two and Turpin, Primrose, Red Pit . . . ten on 'em round Sling, besides bits of poke holes. Because of the rock, timber wasn't needed in some . . . Under Milkwall I'm talking about - never a stick of timber, Now in Number Three, double timber, 'twas broken ground . . . two shifts were worked in there to make the most on't when you could because of the water like I said.

For lighting in the mine we used fats and candles. Fats were very dear - they were a foot long and as thick as your thumb - they'd stand the wind better. We

had to buy our own - the miners had to buy 'em, the mine owners didn't buy 'em - oh no, they didn't buy 'em. Clayed-up they were - a bunch of clay round the top so's only the wick was showin', that 'ould make 'em last longer. We had to buy our own billy as well.

We wore moleskin trousers, stiff white cloth - well they were white when we first had 'em but they soon went red. And we wore yorks with 'em, and our pit boots had any amount of nails. We kept our shirts on at work, 'twas very cold in an iron mine, very airy. Just a cap on the head. Our food down there was mostly bread an' cheese. Home baked bread, a cabbage leaf under while being baked. Beautiful it was - oh, you could clean it up - 'twas good stuff. And cold tea with a bit of sugar but no milk.

We had some hard times - we had to scrat on.

Jesse Hodges was born at Cinderford in 1907:

My father left school when he was twelve and went to work in the iron mine at Edgehills. It was one of those iron mines that went down like a pit - down a shaft. Down to the lower levels where they got the fairly raw ore which was put into ships. Four chairs, one at each corner, were put on a skip and it was hauled-up to the surface. The ore went to Cinderford Iron Works. The miners, four or five at a time, went down the shaft in the skip and up again at the end of their shift.

Life was dangerous then, more dangerous than today, there weren't the safeguards there are today. The men held on to the chains, they'd stand evened-out round the skip and were lowered steadily down.

My father worked in the iron mine at Buckshaft, said Mrs Howells of Ruspidge. He was a billy-boy and he mentioned about coming up the rough ladders (they made their own) from one shelf to another. From Buckshaft he went to Lightmoor, the only colliery he ever worked in.

<div align="right">

CHAPTER 5

Daylight on Sunday

</div>

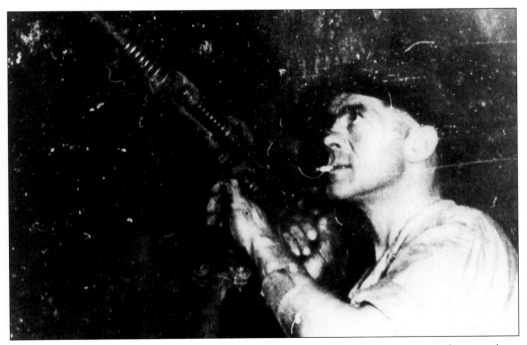

Boring a hole for shot firing. Naked lights and smoking were allowed in Forest pits because there was no danger from gas.

Harry Roberts – 'a most remarkable memory'.

Going down

You were given a brass disc with a number on it, all the colliers were given one. You carried it all day and when, at the end of a shift, it was hung on a nail the management knew you were out of the pit. You also had a ticket - blue one time, buff another - and it had a number on it and this number decided your rate to go down and when you came out of the pit. The bond, first bond, second bond, - going down, coming up, in what order.

At New Fancy they started lowering us at six o'clock in the morning and you were expected to be actually at work at seven o'clock. They started lifting the men at three o'clock in the afternoon and went on lifting until four. Just one hour to get us all down and another hour to get us all up again. In that hour you go down the pit and you got to be down there at seven and when you came back you had to be in time to get your bond ticket.

There were three hundred men and boys at the New Fancy, but when you were down there and you left the pit bottom you wondered what had happened to them all because they'd all be gone. Spread out all over the place, y'see. And those three hundred produced three hundred tons of coal per shift. This was in the 1920s - there was only a day shift. The pit worked on Mondays, Tuesdays, Thursdays and Fridays. There was no work on Wednesdays which was known as 'playday'. There was a period in the 1920s when Lightmoor only worked one day per week for six months.

The banksman was up at the top - he saw to the men when they came up. He pulled a lever to stop the cage running back. He also pushed the drams of coal off the cage when they came up and push an empty one back on. As the men came up in the cage - the cage stopped and the men's eyes would be about eighteen inches above ground level. You saw the bankman's boots and you saw what the weather was like. And the banksman, he'd say, 'This is what you missed today, lads!

Harry Roberts

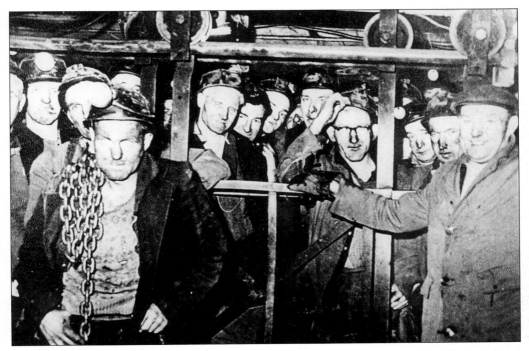

In the cage. 'The cage didn't half go down at a speed.'

No, I never liked riding up and down the pit shaft, the cage didn't half go down at a speed and when the driver applied the brakes 'twas as if the cage was going up again. I remember my first ride down, not tall enough to reach the handrail, - I wasn't quite fourteen - I wrapped my arms around an old man's legs and he put his arms round my shoulders. We were travelling down at a terrific speed and I 'swallowed my heart'.

Eric Warren

The cage dropped like a stone. The memory will haunt me forever - all my innards, not just my heart, compressed as we hurled through the blackness to the bottom of Cannop Colliery. It was August 1936, I was sixteen, and holidays from the Grammar School had just started. 'Let him work his holidays in the pit and decide later . . .'

A dozen or so men were in the metal cage . . . I stumbled out, Fred jerks me along thirty or forty yards to a lay-by. The stench was overpowering; sweat, rats, excrement, pit dirt . . . Little jobs and jibes, twinkling eyes of rats, dripping water, clanking carts, blasts of foul air when the coal carts rushed through the air doors . . .

Leslie Sleeman

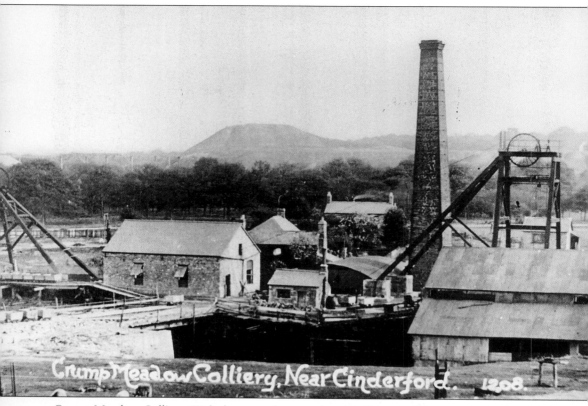

Crump Meadow Colliery. 'Eight hours underground and walk to work.'

The first time down, it was horrible. I was frightened. It wasn't a pit shaft at Eastern United, it was a pit dipple. When I went down, there were forty men going down and forty men coming up - the change of shifts. At Eastern we went down in trolleys, forty up and forty down at a time. We got off at the North Dipple Bond as we did call it and we had to walk to the coal face.

No, there wasn't any hoddin' at Eastern. Before we had the conveyor belts, we had to chuck the coal out as we did get it from the face. The face was one hundred feet long and from there we did throw it out into the road and there were others chuckin' it into the carts.

Not all shifts got coal out. It was all accordin'. If you had two shifts on the coal, that meant there was a lot of road behind to be cut. Men came down and told you the exact place to put the roads. And they knew where 'twas - straight up above at ground level. Anyway, as I said, there'd be a lot of road to be cut, so the next shift had to work at cutting the road in. You had to. To get the rails down in order to get the carts up by the coal face. So that meant one shift out of three wasn't gettin' coal out.

Alan Drew

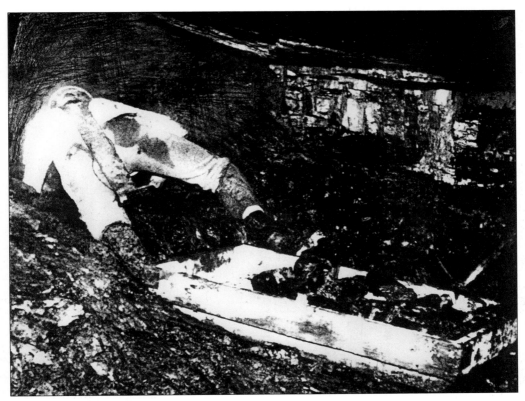

A boy dragging a hod. 'Hodding was the cruelest thing.'

You were paid for coal, you were not paid for dirt. The top might fall in, so you chucked the dirt in the gob. If it fell in a hod road you chucked it in a dram. Cornelius Evans, he used to say, 'Jesu, saviour of my soul; two of dirt, one of coal', as he shovelled. He was always saying that.

Harry Roberts

Hodding

The hod was a shallow box made of wood and on skids, it held one hundredweight, or more, of coal. Hodding continued in some Forest pits until about 1940, although in some of the more recent pits such as Eastern United and Northern United it was never practiced. For hodding you had a strap about five feet long, split into two halfway down - that was the harness, it went between the boy's legs - and the hod was about three feet long. Coal was put in the hod by the filler - he was the one who stopped hewing coal to shovel it in the hod. You'd be on your knees, hitch the chain on the harness to the hod when it was filled. Then you'd be ready on your stomach, with one foot pushing against the coal face and the other against the timber holding up the roof. And you'd grab with your hands like anything and pull and heave and struggle. You'd be sweatin' and the straps would

45

Advertisement in Forest newspapers.

be slipping down your shoulders with the draggin'. An' your shoulders would bleed, you could only work with a vest on them - and your knees would bleed. And when you'd got out of the drift and your load was tipped, the hod was filled with dirt to take back into the pit to be used to pack up the roof with the timber - to fill up behind you.

You went down the mine at seven in the mornin', then perhaps you had to walk perhaps a mile and a half. The only break we had was twenty minutes to eat our bit of food. You were down there, and down there you had to stop, until the butty man said, 'It's time to make for the bottom of the pit - get your clothes on'.

We started comin' out at four. In the winter we saw no daylight as we went in and no daylight when we came out. We only saw daylight on Sunday.

Jesse Hodges

Alfred Warren was born in Collafield, Littledean in 1899, he started work at Foxes Bridge Colliery when he was fourteen years of age. Hodding was his first job:

Hodding was the cruellest thing on earth! That's how we boys started in the pit. I had two bob a day draggin' coal out all day on my hands and knees - you had to 'cos you couldn't get up.

We had to go up to the pit in the morning, stand by the cabin and see all the men go down. If there were two butties on there and they'd got nurn a boy, they'd come back and look around you. We were like cattle in a market. They'd look at you and if your backside did stick out a bit, they'd say, 'He might be able to do a bit of hodding'. They'd say, 'Oh, come on in along o' we today, we an't got a boy.' If they couldn't find a boy to take in they had to do the

hodding themselves.

I worked with Charlie Willstead off Dockham Road - that's who I started with . . . Six days a week and my father and brothers only doing two. I got a golden sovereign and I never put it out of my hand 'til I got home. I give it to my mother and her give me ninepence.

We used to take six sixteens candles every day - sixteens was the size on 'em.

Alfred Warren

Hodding? I went down the pit hodding when I was thirteen [in 1911]. That was at Crump Meadow. Hoddin'? You'd cry all day and you'd cry all night. You'd get sore shoulders, you'd get sore knees. You'd say to your parents, what would you do for my sore knees? 'Put them in the jerry!'

I got a shilling a day - when we did work. Mind, we didn't work that often. It was house coal, which meant we worked in the winter but in the summer you didn't do hardly any work at all - the hooters would be goin' at different pits. [A pit would sound its hooter if there was no work.] Eight hours underground and walk to work - and men were walking from Shapridge [near Mitcheldean] to Crump Meadow. I know one man who walked from Berry Hill. Then you had three or four miles to walk underground and get to the coal face at seven in the morning.

Albert Meek

When we were boys we were sent out to listen for the 'oopers - each pit had a different un - if we heard one we knew there'd be no work for our feythers if that was their pit.

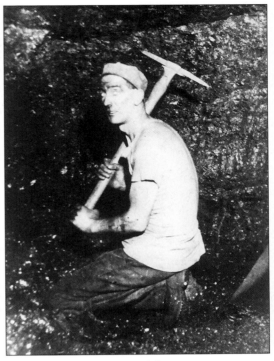

Using a mattock at the coal face.

Eric Warren, son of Alfred.

My first job was hodding at Lightmoor - a working height of eighteen inches - on my hands and knees. The leather straps bit into my shoulders. And when I got wum my shoulders and knees were raw. My feyther said 'you want to bathe 'em with water from the pot'. With pee, y' know - that did the trick.

Eric Warren

47

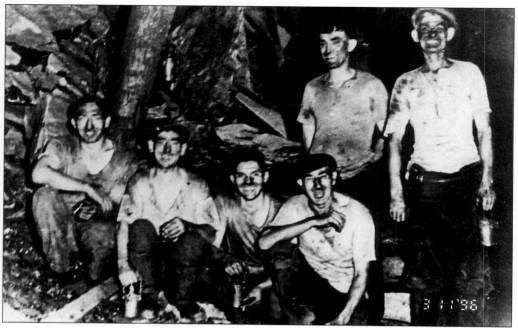

At the setting in the road.

I had a wik, hoddin', only a wik. When I came home I lay on the sofa. Grandmother said 'What's the matter with you?' 'Nothing, Grandma', I said. Then she took a look at my shoulders and saw how sore they were. Then she took my trousers off - oh, my privates were like raw beef. 'Good god', said my grandfather, 'I never knowed the job was as bad as that.' And he stopped me goin' hoddin' any more.

William Thomas

The Butty System

He said to me. 'Bist thy name Roberts?' And when I said it was he said, 'Right we be butties'. His brother was there and away we went. Suddenly there was a wall of blackness and a steep hill to go down and I lit my lamp like the others and they had candles as well. At the bottom was mud which we squelched through until the ground rose a bit. Then we came to the first air door I'd ever seen, made of wood and braddish, it was self-closing and almost an airtight fit.

Eventually we came to the No Coal seam which was two feet two inches, it had a soft rock eight inches thick and then a good top, so there was two feet ten inches to work in. The seam of coal was like a thick layer of jam on a piece of bread. We dug away merrily and calculated how much we'd got at the

48

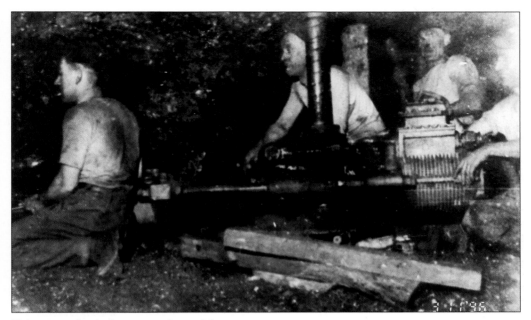
Using a mechanical cutter at the coal face.

end of the week. Soon the top needed timbering so we couldn't get on so quickly. But for the first couple of weeks we got more than our wages because of the butty system. The butty men were sort of contractors - they took the job on and were paid for what was produced and then they paid those who were working for them. The rate was three and sixpence a ton, but when the owners found we were getting a day's pay on top of our four day week they re-priced it. The rate was reduced by threepence a ton and in about three months they were only paying two and ninepence a ton - which included cutting, timbering-up, hauling it through the hod road and filling the drams.

Harry Roberts

The butty system - oh, you did the work and the butty men got the money. It was stopped before the war.

Percy Bassett

There'd be three butty men, one for mornings, one for evenings and another for nights, for each stall and two men at a stall. The butty man would have a man he'd pay day wages, the butty men were paid on the coal and the yardage and all the overplus would be shared out between the dree butty men. In the end the miners had a ballot and quoshed the system.

Len Biddington

Three shifts - one man in charge of each place. All money earned was paid out in the butty man's name and then he shared out - they were sub-contractors, taking on the job of getting coal out and hiring men. But it wasn't the men doin' the work who was gettin' the money, the butty men had the biggest helping. The system wasn't liked.

Alan Drew

My father helped to break the butty system so that every man could have an equal share of the money earned at the coal face. At Crump Meadow the money was paid out at the Bilson Offices. The money used to be paid out to the head butty man (like my father) and the men used to come and squat all round the offices, in groups from their places, and the butty men did bring the money and share out between them. The stall was in the butty man's name and the pay bill.

Jesse Hodges

Two butty men would take the main headings and two butty men would take the stalls off the main heading. The butty men were paid so much for coal got out and so much per yard for rippin' the roadways and they were responsible for payin' the men. The minimum wage was seven and ninepence per day, less stoppages and the butty men would share out. If not enough coal was got, the company guaranteed the butty men seven and ninepence per day.

Eric Warren

CHAPTER 6

Food, gardens and remedies

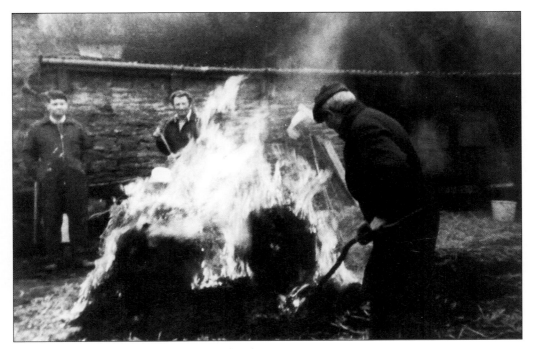

Burning the pig. 'They'd burn the hair off with straw.'

People would never take a house unless there was a good garden and a baking oven, and a pig's cot. That was three essentials.

When we went off to work at the pit we took a tommy bag and in it we had a bottle of tea and some home-cured bacon. Always a cooked meal when you came home, that was the meal of the day.

Albert Meek

Baking

Mother used to put in one of those batch loaves for me. Cut a hole in it and put some butter and cheese down in and then put the crust back. We did prefer cold tea, no sugar or milk, that did quench your thirst better [down the pit].

Eric Warren

We always had home-cured bacon, one or two heavy pigs were cured every year. We kept pigeons and rabbits, we had pigeon pie pretty regular and sometimes rabbit stews. And we had bread puddin'. Mother baked twice a week, an aunt baked on alternate days and we shared bread with her. Mother also baked muffins along with the bread. We'd cut the muffins and put cheese and a shallot in the middle. When Mother baked bread she put a cabbage leaf under the loaves, that made a nice crust underneath.

A.F. Ensor

Mother always baked once a week, ten or twelve loaves at a time - I had three brothers and a father. There used to be a great big rice pudding to cook all night and sometimes a lardy cake - nice and greasy.

She'd put the flour and yeast in a big earthenware pan and then put the dough by the fire to rise - sometimes the dough would overflow. She'd knead it on the kitchen table, then it was put back in the pan again for the dough to rise and then she'd shape the loaves. If we had ham, we used to have scow doughs. That was a flat piece of dough slit with a piece of ham in it and that was put in the baking oven after the bread was out. It was cooked with the ham in it, we ate it hot and it was delicious.

Amy Howells

I liked rabbits in the soup and dumplings, y' know, and carrots - a stew, that's it, a stew.

John Gwynne Griffiths

Bacon pigs. 'We always had home-cured bacon.'

We had a baking oven, Mother baked our bread for a time, but we was such a lot on us that she got old Mrs Jones at the Villa, just below us, at Lower Soudley. And she done the bread bakin' an' muffins. Yes, she used a cabbage leaf. And she had to get the loaves out of the oven. My dad carried bundles and bundles of wood because they had to heat up the ovens and then scrape out the ashes an' get the bread a goin' after.

My mother used to get her Christmas puddin' in the big furnace a goin' in the morning - it was an all day job in they days, brother in the pit and me y'see.

Alan Drew

Mother, her did bake, and make bread puddings and all that, oh dear, dear oh! Lovely bit of bread pudding - soak it in milk, mind, Mother used to soak hers in milk - we could get milk for penny ha'penny in them days.

Making bread pudding? Soak the bread in milk, Mother did hers overnight, next day her'd beat it all up with a fork, ever so fine and put fruit and that in and cook it.

Amy Adams

Mother would make a lardy cake and I'd take it to the baker. Yes, the baker baked the cake. Skimmed milk for puddings with currants, scrutcheon cake, bread pudding. Proper bread pudding.

Tom Gibbs

The Pig

Nearly everybody kept a pig and usually killed it near Christmas. Father always ate the ham first. He'd say, 'Ah, if anything happened to me, after you'd all come back from the churchyard you'd all be back here eatin' ham while I'd been eatin' fat bacon - I'm makin' sure I have some ham.'

Gilbert Roberts

A pig was a great help to people in them days - ours were big pigs, fifteen or sixteen score.

John Gwynne Griffiths

Tom Turner killed our pig. We'd go to old Kicker Hopkins for a bolten of straw to burn the pig. Then it was hung up and cut up later. There'd be a bit of fry for one and another and some chitt'lin's for someone else. When they killed their pig they'd do the same.

We did salt the pig for three weeks, we did rub saltpetre round the ham bones. When they did go up against the wall, Father did say, 'We'll cut the ham first, nobody ain't goin' to have him at my funeral'.

Albert Meek

Mr Turner came to kill the pig. They'd tie the pigs feet and put it on the pig bench and cut its throat. And when it was dead they'd burn the hair off with straw. Mother made faggots and the blood was sold to butchers to make black puddings.

Jesse Hodges

A pig on the wall and a pig in the cot.

Alan Drew

Granny Warren used to mix up slake lime, pour water on it and let it boil. Her used to get a brush and paint the side of bacon.

Eric Warren

Er whitewashed 'im.

Alfred Warren

On pig killing day I allus took the kids out of the road because the pig was a pet. Him was kept separate and him had to have the best. Him had to be in some sort of shape for the bacon.

Eric Warren

When we were children we had to help clean the belly of a pig. When chitterlings were done as my mother did them they were beautiful. They had to be cleaned for nearly a week, and salted, and the water changed every day. Then we plaited them and boiled them. Yes, Mother used to make faggots. Nothing was wasted. Home made lard. Scratching cake.

Doris Harvey

55

Hedgehog

There was a family of Gypsies - true Romanys, name of Johns - near us. We used to play with their children - we got on well with them and they taught us to make pegs. The old lady asked us if we'd like some sandwiches. We said yes and after we'd eaten them she said 'Did you enjoy them? They were hedgehog sandwiches'. We did enjoy them. Just like chicken the hedgehog was. We learned how they cooked them. The hedgehog was put in a ball of clay and then put in the fire. When the ball of clay cracked, it was raked out of the fire, the skin and bristles fell away with the clay and left the flesh.

The old lady wore several layers of black skirt, a shawl trailing the ground and a man's bowler hat. She had lovely, large gold earrings and her hair was plaited at the back. I went to her funeral, they burnt the caravan. The Johns were greatly respected; they lived at Sling and went hop-picking in season.

Cyril Elsmore

Wine

My father gave all his wages from the pit to Mother, he only had forty cigarettes a week and an occasional bottle of whisky. But he made plenty of wine - thirty-six gallons every year. Every morning he had eggs and home-cured bacon, and every night bread, a good lump of cheese and an onion. He had a wonderful garden and kept pigs and fowls.

Eric Morris

The Garden

There was a big garden at the house, Father also had a garden on the other side of the road. We were all brought up to work in the garden. I took to it and so did my brother, as soon as he could use a tool he was out in the garden.

Tom Gibbs

Yes, we had a big garden, we had plenty of vegetables. My father's garden on Ruardean Hill was called 'Cripples Patch', I don't know why.

Amy Adams

My father had an excellent garden, all manner of vegetables. In those days with all the horses, manure was plentiful. We'd go out on to the road, collect it with a shovel and bring it back in the 'coach' Father'd made - it was a little box on wheels.

Doris Harvey

Father was the first man in Abenhall ever to work in the garden on a Sunday. And people up at the Point, they did cry shame on him, but him'd got no other time to do it, look. That was a long time ago, but no, nobody wouldn't work in the garden on a Sunday when I was a boy.

John Gwynne Griffiths

Reynolds Kernel, that was an apple that bit you back. Sharp and frothy, you could bite them and they'd froth in your mouth.

Cyril Elsmore

Most of the cottages in Woolaston had a productive vegetable garden, some of the flower gardens were very well cared for as well. Nearly every cottage had a pig sty at the bottom of the garden. The local postman was also the local pig killer. The cottager cured his own bacon which was eventually hung on the wall ready for consumption.

Many cottages had a small but productive orchard, with apples such as Blenheim Orange, Annie Elizabeth, Tom Putt, Brandysnap, Cissie and some varieties of cider apples. Most smallholders and all farmers had barrels of cider; to give the haymakers and as a general 'cure-all' and winter comforter.

Douglas Oliff

My elder brother and I used to do the gardening, we used to plant the garden out of necessity - we grew two or three hundredweights of potatoes, cabbage, carrots, lettuce ... There was always plenty of horse manure on the green. Men would go and get it with shovels, buckets, wheelbarrows. Why, there'd be up to eighteen horses on the green and forty or fifty sheep and there'd be geese on the green. Many's the time Mother's been out at three in the morning driving horses out of our garden. We didn't have a pig, but we had fowls, Mother used to sell eggs, and fat cockerels at Christmas and get seven and sixpence each for them in their feathers.

From the *Dean Forest Guardian*, 15 August 1941.

There was always somebody who'd sell pig meat, it wasn't always fresh and so it was soaked overnight in vinegar. Beef was eight or tenpence a pound, butter was dear but we never used margarine.

Harry Roberts

Mrs Howells.

Remedies

Father believed in herbal remedies and as children we drank quarts of elder and mint tea when we had colds and it usually worked. He dealt with W.E. Box of Plymouth and sold their indigestion pills which became very popular with Foresters. His younger brother, Owen, who was delicate, became very ill, so ill that the Ruardean doctor gave him up to die. My father asked if he could give him something, the doctor replied that nothing would avail, 'He can't live to morning.' All that night Father gave Uncle Owen nettle tea as fast as he could take it, until he fell soundly asleep at 5 a.m. My father walked in exhausted, but he was so joyful and kept saying how beautifully the birds kept singing as he walked the mile over the hills. The doctor was astounded and Uncle Owen lived until he was over eighty. Father also treated my cousin's bad leg - caused by a rusty nail - by covering it with a plantain leaf, and the leg soon healed.

Kate Meredith

Mother had this cure for dropsy, she made this tea from gorse and drank it. Parsley was used for a water complaint. There was ellum for fevers - to keep the temperature down, - she put black mint with it. Gran Butt's remedy was an ointment made of lily leaves and that clears out all the pus from an ulcerated leg.

Amy Howells

St Anthony's Well, 1932.

There were two doctors in Cinderford, they got paid through the colliery every man that did work there - we did pay through the colliery - so much in the club every month.

Old McCartney used to do everything from setting limbs to drawing teeth. Old Katie Meek had one out and him didn't stop runnin' until him got to Factory Row. There was no gas or anything then, you had to stop and have it, mind. Old McCartney made his own medicines and he had this big vat and the stuff was always green. He used to say, 'There they be, fill their guts on a Sunday and come to me on a Monday'.
The colliers had good first aid teams. Anyone underground with a broken limb, they'd set it there and then, they'd set it with a couple of mattock helves that was there.

Albert Meek

They had remedies for rheumatism and lumbago - men in Cannop were up to their waists in water. One remedy was a piece of old blanket wrung out in warm water and put on the patients back and then a flat iron, nicely hot, pressing it, steaming it but not unpleasant - the moist heat relaxed the muscles.

Elderflower, ellum blow, the queen of all remedies - colds, flu, pneumonia; also used as a poultice. Blackcurrant jam made into a drink for colds and sore throats. Brimstone and treacle to clear the blood. House leeks for eye trouble.

And St Anthony's Well, it bubbles up clear spring water at a constant temperature all through the year. It was a great well for skin diseases, burns and all sorts of things. People had great faith in it. It certainly did help with skin diseases. When I first came to Mitcheldean, I knew of people who used to go down to St Anthony's Well with skin trouble, burns, scalds or eye troubles.

Mrs Hayward of Cinderford was a herbalist:

Her word was absolute iron law . . . If a man had a little look at the [inside of] bandage, it was, 'Out, you get out!' She had a great knowledge of herbs but she never gave away a secret . . . You know, she was a wonderful person.

Marie Hobbs

The skin of a grass snake round the neck until it rotted away was a cure for the weak chest of a child. Goose grease was used for a cold on the chest. For a fainting fit burnt feathers were held under the nose. Then there were 'opening' medicines, senna pods, castor oil, epsom salts. And for a festering whitlow, a small lump of white soap, mix it with sugar, mash it until it's a smooth paste, then spread on dressing and leave it for a couple of days.

Ted Ball

At a medical inspection at school, the doctor walked round to the back of Lewis Little to look at the carbuncle on his neck. Suddenly the doctor said to him 'Look at that picture on the wall.' To do so Lewis had to stretch his neck and at that moment the doctor sliced off the carbuncle and caught it in a rag he was holding.

For chilblains on the feet, place in a pot of own urine. Brimstone and treacle good for the blood, liquid paraffin or goose grease for bad chests. For asthma, my grandfather got gorse newly in bloom, boiled it and inhaled the fumes.

Signs of death; a bird falling down the chimney, a picture falling off the wall, a dream of teeth falling out.

Harry Roberts

My maternal grandfather was a do-it-yourself physician. If you had an ache or pain he had a cure for it. Chesty coughs would produce his aggermony tea [agrimony] or coltsfoot leaves, dried and infused. The juice of house leeks for stings, styes, burns and scalds. Warts were rubbed with raw meat which was afterwards buried and as it rotted so the warts disappeared. Lemon balm tea for stomach cramps and pennyroyal tea for the wind - both grandparents were martyrs to 'the wind'.

Parsley, dried or fresh, was good for the kidneys and dandelion leaves in the spring cleared the blood. Grandad was partial to the tiny, bright, yellow-flowered tormentil, which he called 'tarment' which he used as an infusion to bathe his feet. What with his bunions, hammer toes and corns this did not seem to be one of his most successful remedies.

All our family seemed to be obsessed with bowels and the regularity thereof. Every Friday night was syrup of figs night. Senna pods were stewed in water and then prunes were added. As soon as the swallows returned in the spring we were dosed with brimstone and treacle 'to clear the blood'. This was actually quite pleasant to take but it did dire things to you at the other end.

Croup and whooping cough were treated in Cinderford by taking the young patient to the gasworks at the bottom of the town to breathe in the fumes. Likewise we were usually shepherded outside when the roads were being tarred - another good remedy for weak chests.

I have left until last the queen of all Forest remedies - Ellumblow tea. The pungent flowers were gathered, dried in the sun and stored in paper bags; a good handful was put in a jug, boiling water poured over, covered with a tea towel and left to infuse. This evil smelling brew had to be drunk willy-nilly. Feverish colds and flu were treated by it. Poultices of it for sprains, aches, also for boils, carbuncles, and 'gathered' fingers - whitlows and such. Elderberries were also favoured, made into a syrup and used for coughs and colds. But ellumblow seemed to be the universal panacea; thankfully, the only use it didn't have was for constipation.

Elsie Olivey

Mrs Poot of Clements End made ointment from herbs. Her remedies had been handed down from her grandmother and mother, but she wouldn't tell anyone but her daughter.

Mrs Goddard

Celandine and fresh liquor out of a pig (fat from around kidneys), put in an oven, add a little salt, render and store in jars and use as an ointment for skin troubles. A sweaty pit sock round the neck to cure sore throat. For bladder, kidney troubles and urine infections - parsley boiled.

Marina Lambert

Elderberry flowers and berries. 'Ellum blow, the queen of all remedies.'

For a sore throat chew a raw sage leaf - unpleasant but effective.

We were given a mug of senna tea every Saturday morning. Once I tipped mine in the garden and my sister saw it and I had a good telling off and was watched after that. We had epsom salts, enough to cover a thrupenny bit - on a spoon every morning. But we never had much wrong with us, we had plenty of cheese, vegetables and home-cured bacon.

Amy Hale

CHAPTER 7

Not a penny off the pay

A police escort for Forest miners returning to work during the 1926 strike.

During the 1914-1918 war and for sometime afterwards the coal mines were under the direction of the government. When the government handed the mining back to private business in 1921 the coal owners called for a reduction in miners' wages and a return to district agreements. District agreements, no less than wage reductions, were unpopular with miners. District agreements meant that men working in inferior pits received less money than men working in mines with richer seams. Naturally the miners rejected both of these proposals, whereupon the owners started a lockout. At first the railway and transport unions supported the miners, but soon withdrew their support. In April the miners went on strike alone, they remained on strike until July, a total of thirteen weeks. With no resources they were compelled to return to work on the coal owners' terms.

In 1926 the coal owners terminated an earlier agreement and proposed a new structure which cut the miners wages but retained the owners standard profit. Accompanying this proposal was a hint that an eight hour day would enable the owners to employ fewer miners and so offer higher wages. The Miners' Federation rejected this and said, 'Not a penny off the pay, not a minute on the day.'

On May Day the owners started a lockout. Two days later the miners went on strike. Other Unions supported them, it became a general strike. The general strike lasted nine days, the other unions then deserted the miners. The miners were left to fight their justified and heroic stand alone. They and their families suffered great hardships and poverty, many became destitute and many a belly went empty. It was a brave but forlorn stand, and after twenty-six weeks the miners returned, defeated and were compelled to return to work and to accept an eight hour day, lower wages and district agreements. There was also unemployment among the miners as well as debts incurred during the strike. The owners held the whip and had no scruples about using it.

After leaving the iron mines Frank Joynes went to work at the New Fancy Colliery until 1 December 1915 when he joined the army:

I enlisted at Coleford Police Station, the only time in my life I've been in a Police Station.

In April 1919 he came out of the Army and returned to the New Fancy, later he went to the Princess Royal Colliery:

During the 1921 strike we got no pay, no money or anything. Thirteen weeks we were out and at the end of it I had nothing. Nothing, nothing! My brother who worked at the lime kilns helped me out.'

Yes, said his companion, also a retired iron and coal miner, if you owned your own house in them days, you could yut this! He thumped the stone wall of Sling Miner's Arms. Yes, you could yut this for all they cared. If it hadn't been for our bacon on the wall, we'd have starved.

In the 1926 Strike, we had tickets - for three and ninepence - to exchange for food. I changed mine at E.J. Smith's - the Board of Guardians were supposed to pay back. I went back to work before the end - P.J. Perkins's pit, a good un, down at Fetterhill, just behind the brick works - until it closed. Then in 1929 I went to Bownes & Marshall's pit, the Mapleford

The committee that organised meals at Bilson School for miner's children during the 1926 strike.

Gale, between Ellwood and Little Drybrook. I stopped at the coal face until 1960. I got knocked down by a piece of coal at the end.

Frank Joynes

1926, that's when I lost my job with my brother, at Christmas. We were mates at Crump Meadow and were in that thin seam. He decided to go back [to the pit] because we hadn't got nothing - it was hard times, mind. I said 'I byunt comin'. We was workin' for ole Gil at the time. Well, we wasn't workin' for 'im, but we was doin' a bit of summat. We could go rabbutin', and 'im did chuck us some rabbuts - we wasn't starvin'. We'd go an' help on the farm. But our Jack decided to go back an' they kept askin' I to go back and I said, 'No, I bent a comin', I shan't go back, I be a Labour man and I be on strike.'

We wasn't as hard pushed as some, but I ain't sayin' it weren't hard in the strike 'cos it was. We had a good big garden, we'd got plenty of spuds and greenstuff and Mother baked her own bread.

Alfred Warren

There was no social security, no nothing.

Eric Warren, Alfred's son

There was free meals for the kids at school.

Alan Drew

I can remember havin' a sandwich; dry bread, corned beef and skimmed milk.

Eric Warren

64

Forest of Dean Miners' Association.

Local Colliery Owners' Proposals.

AN EMERGENCY MASS MEETING

WILL BE HELD ON

SUNDAY NEXT, JULY 11th, 1926,

AT

THE SPEECH HOUSE.

MR. JOHN WILLIAMS (Agent)

Will ADDRESS the Meeting upon the Question of the FOREST OF DEAN COLLIERY OWNERS' PROPOSALS as Posted at the Pit Head.

Chair to be taken at 11 a.m. by MR. D. R. ORGAN.

All the infants at St Whites School [Ruspidge] who were miners' children were given dinner at school. Women volunteers did the cooking. One meal a day and we went back on Saturdays just for dinner. We used jam jars for cups. It was a very rough time for miners and their families.

A.F. Ensor

They used to feed us children. We marched to Bethel Chapel. They went round the butchers and got bits of meat; peas and meat in a big boiler and they made soup. That soup was good.

Gilbert Roberts

The conditions we had to put up with were terrible. I went to school and we sat in the class and we had no food in the house. We marched from Steam Mills' School to Bethel Chapel for the only meal we had in the day, and that was soup. And comin' home and sittin' out on the bank by my home and seein' the mounted police escortin' the blacklegs home. And they'd come up around and more or less harass you. I'll never forget that - how could I? My father was a miner, my brother was a miner, and they used to go in the woods and chop wood or loll about on the banks - it was about all they could do. They used to shout at the blacklegs - those that went to work - that was why they had the police - to escort them.

Jack Pritchard

My late brother, Horace, well, he'd been off work for such a long time and eventually he went back. Then them on strike would come around and if they knew you were goin' back they would come outside your home an' batter pans and tins an' make a hell of a row. No fightin' or anything like that y' know. And I can remember a couple of occasions, my brother an' a few more in Soudley, the mounted police came down an' watched them into Eastern an' back.

Not many went to work durin' the strike but there were some. Out of necessity, y' know, because nobody had got anything. They were all in the same way, some stuck it out, but others had to go back to get a shillin'. Back in those days it was pence, yes, you could say it was pence.

Alan Drew

At Foxes Bridge and at Eastern they brought the horses up during the twenty-six strike - they were over by Cullimore Bridge and Lightmoor Horses were at Hart Green.

Alfred Warren

They put a piece of sacking over the horses heads when they first came out. They didn't know what to do, they'd been in the dark for so long.

Alan Drew

In the '21 strike the horses came out. One from the New Fancy ran away. It got to the bottom of the green, by the Dog Inn, then it fell over sideways and got stuck in a deep ditch, couldn't get out either. The pig-sticker was sent for and he came and killed it with a humane killer.

Harry Roberts

In '26 the Fancy horses were brought up and taken down to Awre where they stopped while the strike was on.

Percy Bassett

Strike pits

The miners and other Foresters needed coal during the strike so the miners, probably all free miners, dug for coal which was near the surface. They sold some of it in order to get some much needed money.

Nearly everybody was digging around various places - down at the furnaces. Our Derek did, getting nubbles of coal. There was lots of coal found that had been flung out as ash.

Alan Drew

One of the places where miners got coal during the strike was just off the road almost opposite the Fancy. There was a four foot seam of coal there only eight feet down. They'd dig a square, twelve foot by twelve foot, chuck the dirt out of the way, and there they'd have four foot of coal. They'd get that out and go in three foot on all four sides - under the dirt. By only going in three foot they didn't need to timber-up. One man ignored the rule and went in further and got killed. Then they'd start the whole process over again six feet away and chuck the dirt in the first hole, and then on again filling the previous hole. I was only twelve then and still at school. Lew Little, he was at school with me, but he was eighteen months older and he went there to help his father and brother. He was at it for six months and never went back to school. The coal had to be guarded at night. Lew, who was on guard at one time, was found fast asleep leaning against a tree trunk next morning. A consortium of lorry drivers bought and collected the coal and paid £2 per ton,

A.J. Cook, General Secretary, Miners' Association of Great Britain.

twice the pithead price.

Harry Roberts

In 1926 there were these strike pits - there was at Steam Mills. Oh dear, there were two brother sorting out timbers from a stack for a pit . . . They flung over the stack and there was a boy sitting the other side and some timber flung over killed him.

Gilbert Roberts

67

Miners' meeting near Speech House during the 1926 strike.

To the Workhouse

My mother and I, our family were turned out of our home because we couldn't pay the rent. How can one forget that? We went to Westbury - I spent several days in Westbury Workhouse. And to have endured that. There was no food, there was nothing. We had to rely on what was given to us - by voluntary bodies. I can well remember a load of fish coming from Russia and being distributed around Ruardean Hill. I can well remember it although I was too young to understand what it was all about or what was happening. But to think - we had fish delivered from Russia. It came up on the railway and my father was one of those who had to dish it out to locals so that they had something to eat.

Jack Pritchard

Charlie Mason [of Brierley] led miners down to Westbury Workhouse for food. After the strike was over he wasn't allowed back at his pit. It was seven years before he worked in a pit again, this time at Norther United.

Gilbert Roberts

The Poor Law Institution for East Dean was the Westbury Union or Workhouse as it was generally called. During the '26 Strike its Board of Guardians was not sympathetic towards the miners and their families, despite their desperate plight. A crowd of over four hundred miners, women and children once gathered outside the workhouse, but this did not soften the Board's heart. Later, almost three hundred women and children arrived and asked for admittance. Ivon Adams, who was a boy during the strike, joined a contingent from Pillowell and district that marched to Westbury Union. 'They gave us bread and cheese and then sent us away,' he recalled some years ago.

Victims

Jack Pritchard

I always remember my father saying, 'We went back for less money and whatever did we come out on strike for?' But at least they did come out and they did show some solidarity among themselves and know who was who and what was what. And I believe it was the start of a long haul for miners to have some rights.

My father couldn't get a job in the pit after the strike - he wasn't a leader but I think he was victimised all the same. And it was a long, long time before he got a job in a pit again. He had worked in Crabtree Hill pit and eventually he got a job in Northern United, but it was a long time after almost everyone else got a job again in a pit - well, Northern didn't open until 1933 or 34, so you can tell.

In the meantime he worked on the road at Highnam Corner [just outside Gloucester] and he walked there to a job. And he said he was threepence a week better off working at Highnam than he was on the dole. Other men from our district also worked there and an old wagon used to take them. Later on he worked on the road from Brierley to the Pludds.

Oh, I forgot, in the early thirties he worked at the True Blue, a pit owned by the Wintle family in Ruardean. It was in '34 or '35 when he got a job at Northern. When I left school at fourteen, my father said, «You're never not goin' down the mine.' My elder brother went down the mine and when he came out from Crabtree Hill he was marked by hod straps and Mother used to put grease or something on him where he was so sore. But he didn't have much of that, not hoddin', my father packed him off to London.

Albert Meek

I got cause to remember the 1926 strike, I was joint secretary of the Union in Cinderford. And I was victimised seventeen months for that and so was Jesse Hodges, the other joint secretary. We managed somehow during the strike, although we never had any help from anywhere, but we never went without a meal. We had good neighbours - old Bill Wilkins, we were mates, he had a big garden and what he'd got I could have 'cos we didn't have a big garden.

Eric Morris

My father was out of work from 7 May 1926 to 11 November 1927 and he never had as much as a penny from anywhere.

John Gwynne Griffiths

I was up here in the Forest during the strike. I was in Waterloo. We didn't have no Union money, but we did have summat from Russia so they did say. 'Bout three or four shillin' they did send and that had to last a month. I did run into debt - I ain't ashamed to say it - up at the shop at Woodside. I had all the food I wanted and I think I owed him 'bout £40, but I paid him, mind. His name was Willy White. Willy White, he was good enough to let me have the things and I paid him back.

CHAPTER 8

Trades and traders

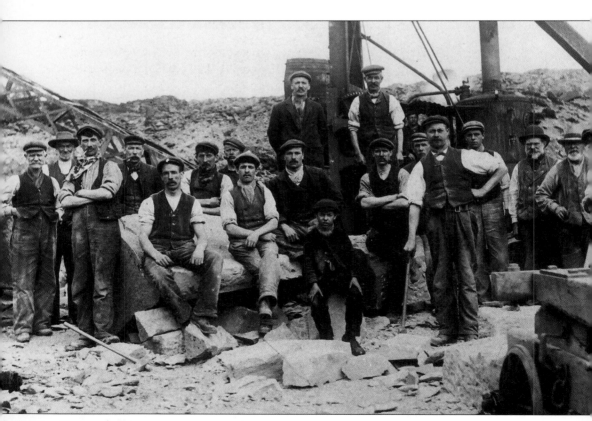

Quarry workers.

William Thomas. 'My job was to draw the burnt limestone out.'

Lime Burning

There were numerous lime kilns in the Forest of Dean - there were kilns at Bream, Edge Hills, Highmeadow, Longhope, Lower Lydbrook, Milkwall, The Plump, Upper Redbrook, Symonds Yat, Whitecliff and others. Limestone was quarried and burnt in kilns for lime, the lime was used to make mortar, for whitewashing and for spreading on farmland.

There were six lime kilns between Whitecliff Farm and Whitecliff Quarry and five by Whitecliff Quarry. My grandfather and my Uncle George burnt lime - one on one side of the road and one on the other side. There was a kiln at Cherry Orchard Pitch - a small quarry supplied limestone to Monmouthshire County Council for road making - and down Redbrook Road there were two kilns.

I used to fill carts with burnt lime for my grandfather (I lived with my grandparents). Before I went off to work my grandmother would cut open some of her home-baked cobs and put some home-cured bacon in them - the old Forester always had home-cured bacon in the house.

My job was to draw the burnt limestone out of the bottom of the kiln - there were little archways inside the main archway. I'd shovel the lime out of the kiln into a wheelbarrow - keeping a look-out for stone, it had to be lime goin' in the carts, not stones, I tipped the lime from the barrow into the cart. Grandfather sat on the side of the cart and watched every barrow load I tipped. When I'd finished, he'd say, 'That's not too bad, Will', and I'd say, 'Not too bad'. Then he'd show me a few lumps of stone he'd put down by the side of the cart and say, 'Ah, but look at this stone, there should be nurn'.

Eventually he'd pull out his watch and say, 'We might as well have our bread'.

71

Lime kilns at Edge Hills.

We'd go up on the top of the kilns and he'd put my slice of bacon or ham on a flat stone on top of a kiln. The stone was very hot - it was red hot on top of the kiln - and that would cook the bacon and with a forked stick he'd get it and put it in my cob. I never tasted anything else as good. Grandmother always baked her own bread. By God! The smell of that bread - all on 'em in Whitecliff road baked and as you went along you could smell it something wonderful.

All quarry work was done by hand. You'd have a hammer and a drill to make the hole for the gelignite to blast the stone - one man struck the drill, another held it and turned it. After every strike you turned the drill - the timing had to be perfect if two on 'em was strikin'. Every so often you took the drill out and got the dust out and poured water in the hole to cool the drill - you made a ring of grass around the drill to stop the water splashing. The first hole I done, Uncle George said, 'Now, Will, I'll see if thee be any good.' And he put his hand in his pocket and pulled out a penny. 'Now listen, Will,' he said and dropped the penny in the hole and 'bomp' it went. 'That ain't bad, old un,' said Uncle George, 'if you hear "bomp", the hole's all right.'

After drawing lime, we'd course the kiln, make airtight the two small arches at the bottom. There'd be a pile of coal on top of the kiln, then the limestone. Smoke bellowed out but 'twas healthy smoke and the stone would be red hot for days - it got cooler as it went down. There were three phases in lime burning Grandfather said, 'Hot, cool, cooler.' Burning continued, the kiln never went out - there'd be a red hot glow at night - unless there was no call for lime.

During the hard winter of 1947 there wasn't any work in the quarries so I went and got a job in Waterloo Colliery.

William Thomas

Stone breaking

Dad worked at Bullo Railway sheds and then he had a job firing the boilers at Wallsend Colliery at Howbeach, until it closed. While he was unemployed he had to walk from his home at Soudley to Newnham three times a week in order to get his dole money. If, for any reason, he missed going he was classed as having worked that day and a deduction was made in his money.

When there was any road work, he was one of the men the County called upon to work. He also had a job breaking stones - loads of stone were brought by steam wagon and tipped alongside the road. Each load was about eight tons, each stone was about the size of a bucket and this had to be broken into two inch lumps. Three hammers were used, a sledge-hammer for starting and then a smaller one and a small one for the final breaking. There was an art to this stone-breaking - the stone had to be broken with the grain or you'd end up with it the size of a football and would only be able to chip bits off it. For breaking one load the Council paid ten shillings. Mr Witts from Ruspidge used to break stone and he only had one hand - when they could manage it, the lorry drivers would bring him a load of smaller stones than usual.

Alan Drew

Mr Witts lost his left fore-arm in a pit accident (he was fitted with a hook) and the colliery paid him seven shillings a week compensation. At this

Alan Drew.

time Shakemantle quarry was in full production and supplied stone to be delivered to roadsides for making and repairing the roads - these heaps were a common sight - and Mr Witts got a job breaking the stone at the roadside. Rain made no difference to Mr Witts, rain or shine he just went steadily on breaking stone. And from time to time an official came with a steel ring and made random checks to see that the broken stone would pass through this ring.

Harry Roberts

Tom Dunn, wheelwright, and his wife.

Wheelwright

The roads around Awre were still of crushed stone, motor cars were very few, the main form of transport was still the horse and cart. The pony traps were now fitted with solid rubber tyres, but the carts, wagons and milk floats had wooden wheels with iron tyres.

Some of these were assembled by old Tom Dunn, the wheelwright, and for me the most intriguing part was the fashioning of the wheels. The hub of the wheel was placed on an elm bole in the centre of the shed. Then the spokes, all intricately shaped by using spoke shaves, were morticed into the hub, and radiating outwards. Finally, the felloes [sections of the outer wheel] were morticed on to the spokes, then the wheel was ready to be fitted with an outer rim of iron.

I have no recollection of any very detailed plans involved in the process. Just a sketch on a fag packet or the cardboard lid of a shoe box, drawn with a flat-leaded carpenter's pencil. Nevertheless, the finished article would be close to perfection.

Meanwhile, at the blacksmith's shop at Bullo, Billy Burcher, the smith, would be preparing the iron bands to the wheelwright's specifications. And when all was ready the wheels would be taken to the smithy to be fitted.

At the forge the coals were glowing, nearly white hot. The blacksmith was a small, tough, wizened man, with close-cropped grey hair, and skin like leather after years of working over the smithy fire. The wheelwright had flowing white hair and a luxuriant moustache, but his mobility was hampered by having only one leg, but, he used to say, at least in his trade he could make his own replacements. He was, as you may have guessed, my dad.

Mervyn Dunn

Tile Works

At Ellwood crossroads they dug the clay for the tile works at Futterhill and at the back of the works was a pit that supplied the coal that fired the clay. The works also made chimney pots, firebricks, pitchers and big glazed washing bowls. These bowls were also used for making rhubarb wine - the rhubarb was bashed by a dolly.

Right opposite was the railway from Parkend - so the works' goods could just

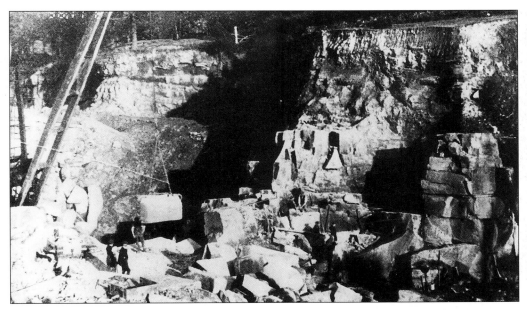

The Point Quarry.

be wheeled across and put in railway trucks. As boys we'd go and cut bracken with hooks and take it to the tile works where it was used to pack the goods for dispatch or used to guard them against frost.

Coal mined in fishleys by free miners was also loaded at this railway siding and taken to Lydney Docks. The coal was taken to the siding by horse and cart. They took two loads a day and then went into the pub to whet their whistles and some would have too much to drink, luckily the horses knew the way home.

Cyril Elsmore

Quarrymen

My father and grandfather were quarrymen. They had a contract to load boats on the tide at the top side of Tintern. There'd be dozens of men there with wheelbarrows, tipping the stone down a shute into the boat below. Later on, father and grandfather lived near Tintern Abbey and walked the ten miles to Oak Quarry at Broadwell and walked back home again every night.

There was 'no wet time'. If it was raining there wouldn't be any pay. One week they walked to the quarry every day and only received one hour's pay. 'We never had enough to buy half a quarter of tobacco,' said Father.

Len Russell

The Brewery, Mitcheldean. 'I remember standing by the gates of Mitcheldean Brewery . . .'

The Brewery

I remember, about 1929, standing by the gates of Mitcheldean Brewery and watching the traffic entering and leaving the brewery. My father drove one of the lorries and he and his mate delivered beer to the Abergavenny area. There was always activity in and around the brewery; lorries leaving or returning after making their deliveries, horses and wagons, customers coming to place orders or to settle their accounts - when money was paid in a free glass of beer was given. Farmers and householders purchased the waste barley, called grains, at four pennies a bushel and fed the grains to cattle and pigs - nearly every household kept a pig.

When barley was received into the brewery the sacks were hoisted to the top of the malthouses. A chain was put around the top of the sack which was then winched up on the outside of the maltings to disappear through a split trap door. There was a loud bang as the doors dropped back into position. So loud was the bang, it was heard all over Mitcheldean.

My grandfather was a maltster at the brewery and when the brewery closed Colletts of Gloucester took it over and continued malting there - an uncle of mine then became head maltster and my father a maltster under him. At times I'd go into the maltings in the evenings with my father when the barley in the kilns had to be turned. Each person wore canvas shoes and the shovels were all made of wood - to avoid the barley being damaged. The day ended with the large fireplace on the ground floor of the maltings being banked up for the night.

Beer from the brewery was sold throughout the Forest of Dean, Gloucester city, parts of Wales and

Herefordshire. Francis Wintle, owner of the brewery, was reputed to be a millionaire and everyone acknowledged him. Children stood aside when he passed, he was a man of great importance and he was treated with great respect.

When I was fifteen I got a job with James Mills, a builder from Cinderford - the year was 1940. The brewery, excluding the malthouses, had been taken over for war work and we were preparing it for a company called British Acoustic Films from London. I well remember James Mills bringing me a roll of coloured prints of the brewery and telling me to burn all the prints. In fact, he stood over me to make sure I did burn them. I have never forgiven him for that.

The first employees [of B.A.F.] arrived in 1940, just a few. I joined them on 3 June 1941. Colletts ceased malting in 1945, British Acoustic Films eventually became Rank Xerox, the plant covering sixty-eight acres and employing nearly five thousand people.

L.J. Tuffley

L.J. Tuffley.

some bread and cheese he'd do some rough digging, scything or tree pruning. For about ten years, like some migrant bird, he appeared with the advent of Spring.

Douglas Oliff

Peg Making

The Forest was a winter resting place for Gypsies. They made pegs from hazel sticks with the bark whittled off, split down the middle about four inches and bound with a trip of thin tin. They also peddled horse medicaments, most of which were prepared to old Gypsy formulae - and they certainly seemed to work.

For many years we were visited by a very polite, bearded old Gypsy who lived in a crudely constructed tee-pee situated in a disused quarry. For a pot of tea and

Employment

There was little employment, apart from farmwork, although the tin plate works at Lydney was one source. Norchard and Princess Royal collieries employed some local men who rode bicycles or walked to work (from Woolaston) which was quite some way away. Some employment was provided by the G.W.R. which required linesmen to maintain the track. From linesman, one could, on occasion, receive promotion to

signalman as the railway had numerous, small, manually controlled signal boxes with signalmen working a shift system. To be a signalman was quite prestigious, but to be a stationmaster, resplendent in an impressive uniform really placed one on the rungs of the social ladder.

The Forestry Commission, then a fairly recently formed government department, employed a few local people. Such open air work, although poorly paid, must have been infinitely preferable to the working conditions in the coal mines or in the tin works.

Douglas Oliff

Bakers

I used to get up in the morning and walk from my home at Newham Bottom down to Joys Green and help make the dough, cut the loaves and shape it. Then Mr Harvey slid it into the oven. There was no electric then, the oven was fired by coke and there was no tellin' whether the bread was comin' out over or under cooked, you just had to watch to see whether it was cooked right or not.

When the bread came out I used to do a bakers' round. With a donkey with two panniers on, I travelled round Hawsley, Joys Green and down Gooses Neck and then up through the Moor Wood - there was no roads then and the donkey was the one means of delivering the bread.

This was the first job I had - I did sixty hours a week - a half-day on Thursdays, starting at three o'clock - and I was paid two and six a week.

Jack Pritchard

Village Shops

In the 1930s and 40s, our village had no electricity, but it had two general stores selling everything from parrafin to pig and poultry food. Each shop had a full range of grocery and a certain amount of drapery. Both were bakers and they delivered to their customers' premises. Another baker, who also specialised in home-cured bacon, baked his bread in the time-honoured method of heating the oven by burning wood in it until the requisite temperature was reached, then raking-out burnt wood before feeding in the hand mixed and moulded loaves with a peel. Particles of charcoal from the wood used to heat the oven were frequently adhering to the loaves, but the bread was well-known for its excellent keeping qualities. A bread devoid of all the 'improvers' and 'enhancers' which have become requisite constituents of the modern loaf. Delivery was by a four-wheeled, horse-drawn, baker's cart.

Douglas Oliff

Baker's Accident

There was a row of houses at Bilson, by the Crump Meadow offices and the gas works. There was a huge heap of coke - oh, fifteen feet high and fifty feet long - in the 1920s, nobody wanted it, everyone used coal. And the ground sloped so the men were able to push the drams of coke from the gas works to this heap. The baker was delivering bread to the nearby cottages one day - and he was getting out of his high cart, his right leg on the step, his left leg outstretched to

Coleford shop. 'Pont and Adams, grocers in St John Street.'

the ground and on a dram rail, he was, of course, getting out backwards. Well, just at that moment, an empty dram ran away down the rails and the runaway dram amputated the baker's left leg. I didn't actually see this happen - but we ran down there, by the time we arrived the 'black van' had taken the baker away, but we saw all the blood on the ground and the blood-soaked cotton wool . . .

Harry Roberts

Bilson gasworks closed in 1955. The black van mentioned was run as a public service, possibly by Fred Munn. East Dean Parish Council was given a horse-drawn ambulance in 1903.

Cinderford Shops

We dealt with Mr Whittle (Cinderford). Anyone who went into the shop could sample the butter or cheese. All the goods were on shelves at different heights and under the counter, everything was cramped-up. Saturday was pay-day for the men who worked there and while Mr Whittle was totting-up the money a boy was sent to the George to get flagons of beer which was then drunk in the shop. Yes, everything was delivered by horse and cart.

Everything was on display at the India and China shop. Everything came [to the shop] in wooden boxes or sacks and these boxes came in handy for making sheds and poultry houses - they'd charge a shilling for them.

A lot of people belonged to the Co-op, the dividend was a big attraction, which could be two and six in the pound.

The Co-op shop in Cinderford. 'A lot of people belonged to the Co-op.'

My mother used to leave her 'divi' in for as long as she could. [There were nine grocers in Cinderford in the 1920s, 1930s.] I think most people got all their pit clothing from Jacobs', I did, and at a reasonable price. You could get a pair of pit boots for 7/11 or 8/11 and a pair of moleskin trousers for about 7/11.

Harry Roberts

All the little shops in Cinderford were making a living with none so greedy that they encroached on another's living. You were waited upon by polite assistants and your goods were delivered to your door. The private grocer even called (in the evening) to get your weekly order. Milk was delivered fresh twice a day - morning and evening. Put into your jug at the door from 1/4, 1/2, and 1 pint measures. Nothing in the grocer's was pre-packed. Butter was cut from a block, there were huge round cheese with rind.

Sugar was packed in bags of dark blue paper - known in schools to this day as sugar paper. I remember how deftly the tops were tucked in and how butter etc., rarely had to have any added or taken off the scales - so precisely did they cut it out. Sugar bags in which the sugar was delivered to the warehouse could be obtained free of charge. Washed and boiled they were made into pillow slips, table clothes, tea towels and all sorts.

Sacks which had contained poultry meal, pig food etc., were used to back rag rugs or for wiping shoes when coming off the garden - and even for washday aprons.

Most sweetshops sold loose sweets and these were put into a sort of cone shape - a square of white paper turned diagonally into a cone, the bottom was twisted to close and the top flap turned over to cover the sweets. My favourite sweets were Sherbert Fountain, raspberry drops, chop, peas and potatoes,

Coleford shop.

cherry lips, tiger nuts.

And I remember getting a paper of pins instead of a farthing change at Mrs Cuttings.

Elsie Olivey

Coleford Shops

The Ironmongers shop, Sydney Young Page, his wife said, 'Yong! Yong!' as if it was a Chinese name. D.C. Evans had a sweet shop with an open grill outside. His son used to invite us into the cellar, 'Come on, chaps, here's Mrs -, I don't think she wears knickers'. And there was a shipping agency - yes, a shipping agency in Coleford - run by Walter Provis. When Coleford flooded he made a paper boat and wrote on it 'Walter Provis Shipping Lines, book here'. It floated down in front of the Angel and Major

Cripps of the Angel didn't like it.

Mr Baker had a lady's outfitter's and two daughters and if they acted the fool he'd bend them over the counter and beat their bottoms with his yard stick.

The Court was held at the Police Station, Superintendent Shewswell used to come up from Lydney on his autocycle and say, 'Have a good look, now. Riding backwards and forwards makes me look a bloody fool.' Alf Lawrence had a fish and chip shop and the first in Coleford with a mobile fish and chip shop. He'd go round Clearwell ringing a bell from his touring car with a barrel in the back. His wife sat in the back with the barrel and did the serving but she got tired of it after a while.

Dickie Staite had a bicycle shop; his wife wanted the lavatory re-decorated - she was very religious and one Sunday while she was at church he whitewashed the lavatory, seat and all. She, in a black

81

Cinderford. 'I got my pit clothes from Jacobs.'

dress, came home from church and was in a hurry to use the lavatory - Mrs Staite wasn't pleased!

And Fred Hose, a dentist - if he couldn't get a tooth out the normal way, he'd put his foot on the patient's chest and something had to give. Mr Evans at the Red Lion had two nice daughters who increased his custom. Frank Blanch - 'See Blanch and see better!' Provis, the grocer in Market Place, Pont and Adams, grocers in St John Street . . .

On Fridays and Saturdays there were stalls in the Town Hall at Coleford; a clothes stall, a cobbler's, another sold hob-nailed boots for mining, Miss Aston sold sweets - all home-made, lovely butterscotch, almonds dipped in brown sugar. And at the far end Masons of Cinderford had a meat stall run by Mr Voyce. And there were paraffin flare lamps at night.

Cyril Elsmore

Saturday Night Cinderford Market

In the Fleece Yard there was a market at weekends. Hodges sold fish, cheap-jacks sold china - there was also a coconut shy. Albert Teague ran another behind Bowdlers where, among other things, fruit and vegetables and lots of swedes were sold. Oh, it was exciting in Cinderford on Saturday nights, at seven o'clock butchers started auctioning meat and they were going well by nine. This was before they had refrigerators and it was said, 'a bad price on Saturday night was equal to a good price on Monday morning.' All the butchers had open windows in those days and they sold from their windows. I worked for Thomas Mason, he auctioned the meat, I wrapped it up.

Sometimes, to make a joint more attractive buy, he would hold up a good chump chop and say, 'And I'll include this with the price of the joint.' I would have

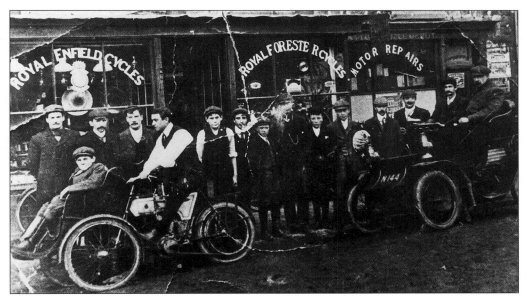

A Coleford bicycle shop. 'Dickie Staite had a bicycle shop.'

instructions to whisk the chop out of sight and pack a few bones up with the joint and if a customer complained the next week, he would then say, 'It was that young bugger.' And he'd call the butcher down below, 'Old fat guts, he knows more about pullin' beer than sellin' meat.' This was because Mr Jenkins who was a big fat bloke, also kept the Fleece. Matty Dawson also sold for Mason and when selling legs of mutton he'd shout, 'Look at those lovely legs, legs like London barmaids with blue garters on.' A leg of mutton sold for four or five shillings. Eastmans and Nicholls also auctioned meat and so did Bill Barnard. Others would be auctioning fish or china. The traders shouted but their shouts were never complimentary about each other. Some of the men who bought meat put it in big red and white handkerchiefs. The Co-op was the first to have a refrigerator and meat auctions finished in about 1930.

On Saturday nights there was a boxing booth by Parry's and Cinderford was full of people.

A. Ensor

To us children in those days it was a wonderful place, all the different stalls. But the stall my granny always called at was Johnny Gough's who made sweets and did a roaring trade. Faggots and peas by Mrs Jones. I used to sit on the bench and they were feeding off these saucers of faggots and peas and they seemed to be enjoying them very much.

Frances Webb

Father was a shot firer at the Flour Mill Colliery and he used to buy the gelignite from Fred Munn of Cinderford. On Saturdays we went from Ellwood to Parkend and caught a train to Cinderford. Father then went to Munn's and got the gelignite which he carried in Mother's frail and we'd go into

83

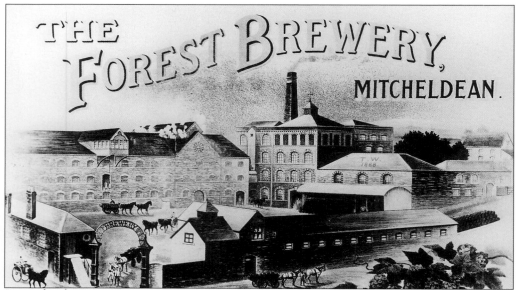

Poster for the Forest Brewery.

Cinderford town. Dad bought meat and black pudding at Mason's and put them in the frail. Next we'd go to Parry's for oranges which also went in the frail.

Then Dad would say, 'You can have faggots and peas and walk home or we can ride by train but only to Speech House Road 'cos we've no money to ride any further.' We always chose faggots and peas and walked home through the woods. The owner of the faggot stall was as round as tall. Cinderford Town Hall was lit up by paraffin flares and smuts were falling everywhere. Mother was worried about the gelignite, so Father put the frail under the bench where we sat as we ate our faggots and peas. Everyone, including Mother presumably, seemed content with this arrangement although there was enough gelignite under that bench to blow up Cinderford.

Cyril Elsmore

Cinderford Market, Saturday nights? Fish, meat, fruit, vegetables, poultry, sweets, clothes, china. We'd wait to last thing at night when stuff was sold off cheap. Mother and I walked from Soudley, we'd be at Cinderford at half past nine at night and get things as cheap as possible. The meat and fish, they had to get rid of it for what it would make, no refrigeration then. Oh god! Any amount of people there. They used to hang about, them as could, times were hard, a ha'penny was a ha'penny. Faggots. They were lovely! They were lovely!

Alan Drew

The trees are green

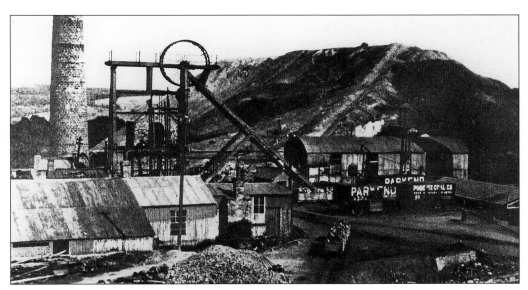

The New Fancy Colliery. 'It should never have closed.'

You could always tell a house coal collier from a steam coal collier. The house coal collier was thicker in the shoulder. He had to lie on his back to work, he did everything from that position. Even with the shovel, he did get his shovel like that and tip it. He tipped the coal as he was laid out. There was times him would get a new blade for his pick and he couldn't turn him - the pick he couldn't turn. Him had to take it out in the road and get the blade turned round so's he could use the sharp end. There wasn't a tougher man in Britain than the house coal collier, he worked hard, played hard and drank hard.

Eric Warren

At Crump Meadow there were coal seams less than fifteen inches. You had to be on your side, you couldn't get on your knees. There'd be a place going in a seam - there'd be lots of different seams going and you'd ask the over man [butty man] about a start on yer own. If he thought you was qualified, he'd say, 'We'll give thee dree bob a ton to get this - that's to get it out and fill the cart'.

I also worked at Lightmoor, yes, I expect it was the best pit. They even had their own railway engine to run the coal down. The shift was from seven in the morning to dree in the afternoon - if you had a late bond you might be there until half past four. It was more than two miles from pit bottom to coal face.

Alfred Warren

There was headings - what we call 'dip yud' and stalls. The old colliers would have deep headings and they drove the loads and they employed a hodder and a filler. We didn't pillar back - all the ground was filled up with the surplus from where they ripped the road to get the height for the horses - they were wagon horses and Lightmoor was a marvellous pit.

Later on, after doin' hoddin', I went with the wheelbarrows. For walkin' you'd carry your candle between your fingers. Going down Rocky it was all lit up with candles, then we had the American 'Justright'. We often hit our heads - oh, you couldn't wear helmets in that kind of ground; anyway, Forest colliers didn't like helmets. Lightmoor only worked one shift. Lightmoor was the finest pit, I started there and I stopped there till it closed.

Eric Warren

All the colliers wore moleskin trousers - they were made from a very, very tough sort of cotton material, they'd last no end of a time, we'd put patches on the knees - that took some doin', it was such very tough material. They were white when we bought 'em, and the fust time we wore 'em, they'd say, 'Who killed the donkey?'

But they soon turned black - you'd be kneeling on rough coal all the time. No, moleskins weren't uncomfortable, you could wear 'em and where you did sweat and after they'd dried out they were hard and they'd stand upright. They'd stand upright when you took 'em off.
Oh, good god no! We never washed 'em. Take 'em outside and give 'em a good beating agen the wall. Get some of the

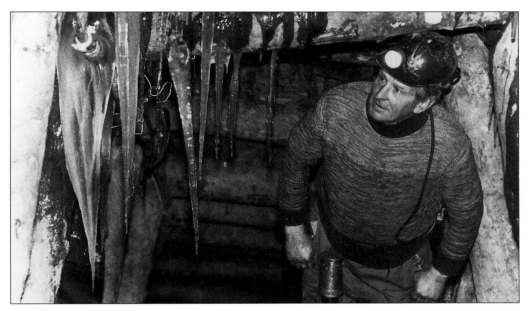

Icicles in Waterloo Colliery.

dust out of 'em, you couldn't wash 'em. Last a couple of years. A lot wore knee pads made out of a pair of old moleskins.

Hob-nailed boots we wore, got 'em and the trousers from Jacobs at Cinderford. We had to buy all our own tools; shovels, pick-axes, hammers, sledges, bars, wedges and lamps - one for the cap as well. Oh, yes, and blades for the picks - shafts with blades in and a key to tighten 'em. When the blades got blunt, we knocked 'em out and took 'em up to the tool shed and they was sent to the blacksmith on top to be sharpened. No, it didn't take me long to get used to it. It was hard, but you had to work. I started in one foot six - a coal cutter couldn't get through. In 1939, when I got married, I was getting eight shillings a day, working at the coal face. Six shifts on days, six on nights and five shifts on evenings.

We did used to ride on the carts, unofficially, mind. You did sit on the bumper or step and put your foot on the hitchings and put pressure on that un to ride down an' that acted as a brake. It was dangerous of course.

But I enjoyed my time underground. You cussed one another and threatened and swarved but once you come up, it was, 'See you tomorrow, old butt.' We were comrades.

Alan Drew

My time agen? Go down th' pit, we was all butties there.

Fred Warren

I liked it at Waterloo, you'd never meet a happier gang of chaps than those who worked at Waterloo.

William Thomas

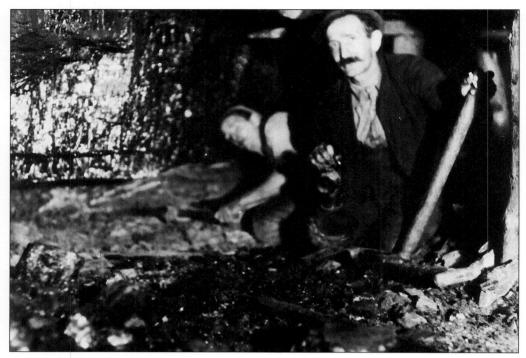

Getting coal out, Lightmoor, 1930.

A deep head entailed cutting through fairly soft rock, but if the rock was hard it meant blasting the rock out. Mr Parker would get his son-in-law to drill the hole, about eighteen inches deep and one and a half inches in diameter. This was done by hand with a racket on the brace. When the hole was cleared and ready Mr Parker put in a stick of gelignite and rammed clay around it. Then he'd light the fuse and everyone got out of the way. We could see the fuse burning like a firework . . . It wasn't really like an explosion, it was just a thump - almost like one of those air doors closing.

Harry Roberts

After putting in explosive, we rammed in clay, the clay hadn't to be wet nor dry. And after the blastin', if the air wasn't good, the bloody smoke was terrible, it would hang about all during the shift, and we'd have to work in it.

Eric Warren

The New Fancy, 1996.

The New Fancy

I started at the New Fancy when I was fourteen - on the screens for ninepence a day - ah, ninepence a day. Then I went hodding - two straps over my bare shoulders - I soon had a sore back - a chain between my legs and working on my hands and knees. One and eleven a day I got for that! Then one day, Mr Lang, the manager came down and saw me and said 'What are you doing down here, you stop up top tomorrow'. Next day the contractors [butty men] said, 'What are you doing up here?' Well, I had a job on the pumps at two and six a day, seven days a week. Then I went along to Stan Nelmes on timber - doin' the roads underground.

We had an old man who walked to the Fancy from Blakeney every night. You could hear him a coming 'cos he wore clogs. He worked on the hand pumps.

He'd sit down by the side. He allus had a candle. He'd tell the time by that candle. You only had to say to him, 'What's the time, Mark?' And he'd tell you the right time - by that candle. He'd be there a-pumping all night long and he'd be half-asleep, y' know.

They should never have closed the Fancy. After it closed I went to Eastern and to Princess Royal. At the Fancy I could get from the top to my place of work below in a quarter of an hour, it took three times as long at t' other two. The Fancy had about the deepest shaft in the Forest, and it were the driest. They hadn't long opened the Trenchard seam when they closed the pit and Mr Bennett, the last manager, wanted to get at another seam half-way down the shaft and put a false bottom in.

Nunky Cooper, who knowed more than any on 'em - well, Nunky Cooper allus said, 'If they sunk a shaft opposite

Boy's Grave - Bicycle Turn - deep enough, all the coal would be coming down instead of up'.

Ah, yes, I'd do the same again - 'Twas the comradeship. If you was buried, they'd get you out. They wouldn't think of themselves. It was the comradeship, you don't get that in a factory.

Percy Bassett

The New Fancy Colliery was the last of the house coal collieries in the Forest of Dean and the proposal to close it met with considerable opposition. The mine owners and the miners were of one accord; the pit need not close, they declared. With adequate machinery, it was claimed, the pit could produce one thousand tons per week and that could be raised to twelve hundred tons. The pit was inspected by representatives of the South Wales Miners' Federation who were satisfied that there was sufficient accessible coal to justify the continued working of the New Fancy. At a May Day Meeting at Yorkley in 1944, John Williams, the Forest Miners' Agent said, 'It's touch and go whether the colliery will continue.' The announcement of closure came two months later - the Regional Controller did not consider the colliery's output justified the subsidies the government was paying to keep it in production. The Regional Authority decided to disperse the men - the pit employed three hundred, most of whom went either to Norchard or Princess Royal. And thus, in 1944, the New Fancy, the last of the house coal collieries in the Forest of Dean, was closed.

Cannop

At seventeen I was on the coal - pillar and stall at Cannop. Then a new under manager from Durham came and introduced coal facing with conveyors. I went and worked on the face and later installing conveyors. Bevin boys from all over the country came to Cannop for training. One of them was six foot six, too tall to be in the workings so he had to work in the pit bottom where it was high enough for him.

Later I went to Northern and when that closed I went to the Rank factory at Mitcheldean. It was so different, I didn't like it, it was bloody awful. Never saw anything like it in my life, I was there twelve years, but I never got used to it.

Harvey Gwilliam

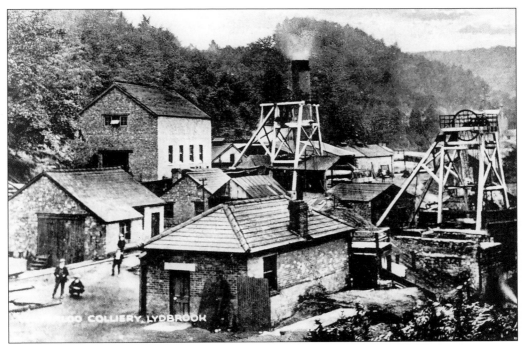

Waterloo Colliery. 'When we came up we looked across at the trees . . .'

Waterloo

When I was at Waterloo about six hundred men were working there but only about fifty or so were colliers - hewers of coal - working at the coal face. There'd be about eighteen at a hundred yard face and thirteen clearing a stint eight yards long. The seam was cut three and a half feet in advance by a coal cutter [machine]. Holes were drilled and about one pound of powder was put in each hole - you had to buy your own powder - and there was a shot-firer on each face. Coal was removed as the conveyor was running and when the journey was being changed the timbers [props] were put in. At Waterloo the men were paid on the tonnage they produced - other pits worked on Stint, the measure of ground opened. Waterloo was one of the biggest takes in the Forest - it went almost under Drybrook Road Station.

We could tell what kind of weather it was up above by the state of the carts when they came down - wet or dry, maybe with snow on 'em.

In the mornings the older men allus got to the pit early. My father allus got there half-an-hour early - at quarter to six for winding at quarter past. You picked up your metal identity disc with your number on it, then you went down. The first sixteen on the first bond had a number one bond check - and so on and they came up in the same order. The winding gear at Waterloo was very powerful - the shaft was ninety-seven yards - and it would pull up two carts of coal at a time with half a ton in each. And in double quick time, there'd only be winding for six hours on a shift but it would pull up a thousand carts in that time.

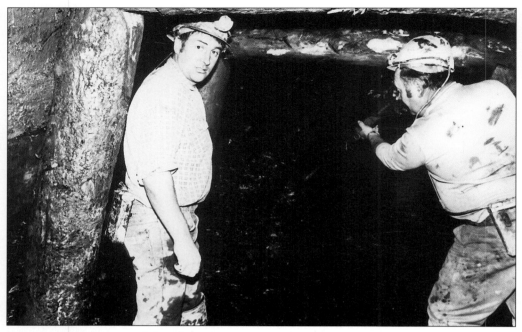

Eric Morris (right) at work in a free mine.

When the main winder was out of commission the men were brought up the water pit. It was a bit frightening - the shaft was full of the steam leaking from the steam pump pipes, what with that and leaking water, it was like being in a thunderstorm, and there weren't any lights either. When the cage hit the wooden cover at the top of the shaft, there wasn't always enough power to go right on up. We'd see six inches of daylight and then the cage would go down four yards and then back up it would come with a bang and maybe get to the surface.

When we came up in the bond we used to look across at the trees by Lydbrook Vicarage. How green those trees were to us, never were trees so green.

In the pit there were no colours, just black, or shades of black, only men's eyes showed white. When you came up from the pit at the end of a shift it was wonderful to see colours. The autumn colours of the trees - that was almost like a reward for working down in the black. As we reached the surface - that first glimpse! Only miners could appreciate to the full the green of the trees, the colours of autumn. Had anyone else walked with us from the pit they'd not have seen what we saw. They wouldn't have seen the blue sky, the green trees that we saw with our eyes.

Eric Morris

CHAPTER 10

Horses

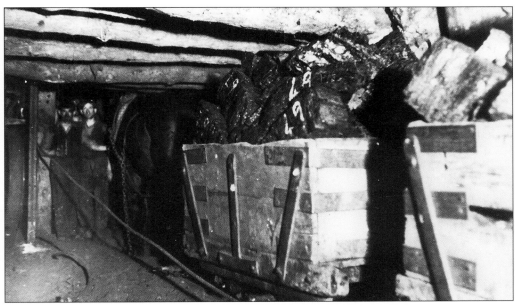

Horses hauling coal in Lightmoor.

Percy Bassett.

At the New Fancy

My father was the main ostler at the New Fancy, he was there nearly all his life except when he drove a four-in-hand for Sir Charles Dilke while he was staying at the Speech House. [Dilke was a champion of the miners and M.P. for the Forest Division from 1892 to 1911]. My father, he lived for his horses. They were all heavy horses at the Fancy, there were about thirty of them. They had to be five years old before they went down the pit and they stayed down there for three or four years. Yes, they worked the same hours as the men on day shifts. Just a couple were kept for maintenance work on evenings or night shifts. Mind, if they was pushed, horses that had been working all day did an evening shift sometimes.

We did go in the morning (I became an ostler later on) and see all the horses out at 7 a.m. Oh, they were fed on chaff [hay chopped-up], oats and bran. Oh, aye, they was better looked after down there

than the men. We stopped down until about nine, cleaned 'em out, putting their muck in a dram, then up we went to breakfast. We lived in a cottage on the pit site, right between the power house and engine; everything in the cottage would shake, the cups an' all would rattle. In front of the cottage was a big pool and the water was always warm, the soil in the garden was warm because of the boilers. There wasn't ever any frost in our garden, we could grow peas and potatoes in the winter and there was always plenty of greenstuff.

Father spent hours and hours with his horses, he'd even spend his spare time in the stalls above ground where a few horses were kept. Oh, he loved horses. Down below mind, if the feed wasn't in their boxes at dinner time, he'd take them back to their stalls. The contractors didn't like that.

If he saw a jagged bit of rock in the roads he'd mark it with a piece of chalk and see it was seen to, it might injure the horses, y' see. They were big horses, some weighed a ton a piece - they weren't donkeys. At Princess Royal and at Eastern they only had ponies, fifty or sixty of 'em. The Fancy carts were heavier and the rails were old fashioned, if dirt got on 'em there was difficulty pulling the carts. We had two horses above ground that pulled railway trucks. And we had one chap who did whistle and he was the only one as could drive that horse.

When horses had to come up, they had to back 'em on to the cage. Then chaps had to be ready, had to be quick, to knock 'em off their feet so as they sort of sat up - oh yes, only one at a time - with their head turned to one side. You'd heard 'em in there a kicking to get into

position and get comfortable. If one was short-winded, very likely he'd be dead by the time he came to the top. When they were underground they wore a sort of cap which covered the head and came down so far over the eyes. And they wore these for a couple of days when they came up on top. No, they weren't blind.

The Fancy belonged to Deakins and then it was sold to Hicks who tried to get rid of the horses. Father, oh, he did love his horses, he spent hours with them. He was still breaking-in horses when he was seventy, then when he was seventy-five he got kicked by a horse and that led to gangrene and the end of him. I then took over as ostler at the Fancy until it closed.

When the horses came in at the end of the shift at half-past two or three, they were washed down all over by hosepipe and when the night ostler came he groomed them. The Manager said, 'We'll shoot all the horses when the Fancy closes down'. But I sold most of them and they went to work in the wood.

There was a fire at the Princess Royal and the foreman said, 'Tie your horses up' - I said leave 'em so they wun't hurt nobody. No, they tied 'em up and when we went down after the fire, they was all stood up and we couldn't move 'em. And I said to the manager, 'There, there's your brains, a horse wouldn't hurt nobody. Where there's danger they get away from it.'

I had twenty-seven years underground. Down there, everybody was together, everybody helped one another. Once I got buried by my legs, I couldn't get from there, I was worried it was all comin' down on top of me, but the chaps came and propped it up and got me out.'

Percy Bassett

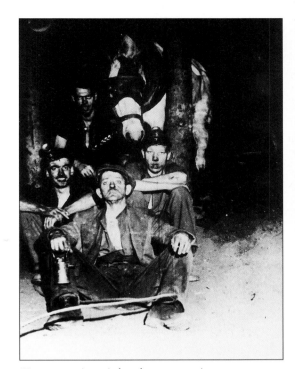

Horse wearing pit headgear at setting.

An Onion For The Horse

The best time I had in the pits was when I was driving horses in the Princess Royal - takin' timber in and bringin' dirt out. I did that for a couple of years. I enjoyed that.

There was one hoss, he'd just come into the pit, he was wild. Just as you was about to put the hook on the tram, he'd bolt. Well, one day, I'd been havin' my bread an' cheese an' onion - it was a hot onion and I'd flung the skin away an' that hoss, he picked it up and eat it. After that I allus took a few onions down in a bag and he'd allus come, and I'd also take beech leaves, oak leaves, cabbage leaves for him.

The horses came up for two weeks every year when the Royal shut down for holidays. Everybody respected the horses. They were blindfolded to bring 'em up and to take 'em down. When they came up the blindfold was taken off when they got in the field, then they'd roll about and gallop.

Donald Johns

In The Woods

Uncle Stan Roberts used to break-in horses. They used to race from Meendhurst Square at Cinderford in breaking-in traps. Kids used to get out in the road to watch. And these horses, being broken-in, they used to go all over the pavements. As well as breaking-in horses for himself and for other people, he had a haulage business. One job was to take the wooden box-like constructions for drams from the carpenter in Church Road to Lightmoor Colliery. He also had a timber wagon and kids going to school used to sit sideways on the central pole of the wagon.

Grindles had a hearse pulled by horses and after a funeral at St Johns, children at St Whites would shout, 'Grindles have come from church,' and we'd get on those axle springs that projected from the rear of the hearse - there was room for two or three. If anyone didn't like us, they'd shout, 'Whip behind! Whip behind!' And without so much as turning his head, the driver would flick his whip and whip us off.

I left Double View School on the Friday and on the Saturday I was working in the woods and in no time at all, I was driving a horse, hauling cordwood. I used to ride on his back to Howbeach which was three or four miles from the stable. We couldn't use anything but a sledge to haul the cordwood because the hill was so steep. Sometimes a runner of the sledge would plough up a large stone and shoot all the cordwood off the sledge.

Harry Roberts

Hauling Timber

I remember when Joiner bought some hedgerow timber from Bullock's farm an' old Syd James had to come right over there to get this timber and he had to haul it up through Littledean up by the church an' he'd got three hosses on there an' they'd got fat an' couldn't get no grip an' he rang through to Joiner, who picked me up - I was only a kid then. And he had to put the lorry on to help

pull an' while he was doin' that I was pushin' the block underneath.

Timber was brought to the sawmills at Soudley by a team of three horses, loaded on timber carriages - some of the timber was thirty feet long. Sammy Jones from Flaxley did some of the haulin' and also a man from Yorkley by the name of Syd James. Syd James, he would walk from Yorkley to Soudley in the morning, do a day's tushing out, then load as many as six trees on his timber carriage, haul them to Joiner's sawmill, unload them and then walk back to Yorkley.

Alan Drew

Timber wagons coming down through Broadway with six horses and we'd hang on the back and slide in our hob-nailed boots.

Len Russell

Tom Williams used to say, 'Talk to 'em, that's the secret with horses, you must talk to 'em.' Tom Williams was carter at the farm where I went to work when I left school. He was also very particular about seeing that they were well groomed before he put the harness on them - and about the harness being comfortable for them. Yes, he'd only to speak to a horse to get them to do what he wanted. One of his regular jobs was taking hay to the pits, driving four horses in line. The hay wagon wheels, you could hear them talkin'. Especially when the wagon was empty - you could hear 'em and know which was Tom's. David Warren, he'd say, 'Here's old Tom a comin' back.'

Mr Ebborn, the farmer, bought timber for the pits - some of it was big timber. In those days trees were felled by hand, with

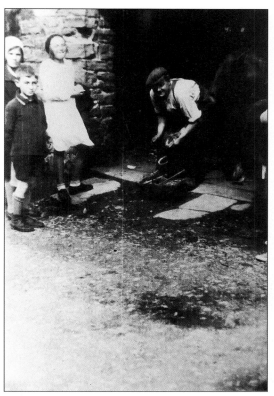

Shoeing a horse at Drybrook.

axes and cross-cut saws, and plenty of muscle and sweat. Oh aye, and with skill, those timber fellers were skilled men, they could drop a stick to fall exactly where they wanted it - yes, exactly where they wanted it to fall.

The horse, Duke, was used to load the sticks on to the timber carriage - we allus called timber 'stick'. To load the sticks, two poles were fastened to one side of the carriage - yes, a sort of ramp I suppose you could say, and the horse would be the other side of the carriage to pull the sticks up one by one - a chain was put round the sticks of course and attached to Duke's gear. Duke would then pull a little bit, pull a little bit, pull a little bit - the stick was sort of snatched up.

Jack Wozencroft, he was only a little man, I was sent with him to over Ross way, loadin' timber and takin' it to Waterloo colliery. We'd do one journey a day. Jack Wozencroft had a horse called Dragon. Aye, Jack was a good little man with horses.

For timber tushing the horses would be in long gears of course - we'd hook the chain round the thin end of the sticks not the butts.

I've spent many a weekend cutting chaff for the horses ready for when they were away during the week - when we went to work the horses always had nose bags. These was slung on 'em and contained their grub, chaff, oats, sharps. When I had charge of horses, oh I'd pinch oats for 'em. When I was workin' at the Grove for Albert Young - I was away tushin' timber in the woods and I'd pinched maize meal for 'em. When I came back they had the half-crowns on 'em and Albert Young said 'What have you been feedin' 'em on?' [half-crowns - dappled marks resembling half crowns - an indication that a horse had been well fed.]

Albert Young also had a contract for road-mending - to spread gravel on the road immediately after it had been sprayed with tar. We'd load the carts with gravel which stood in heaps alongside the road and then with a shovel we'd spread the gravel from the carts on to the tarred road. At that time I had a mare called Violet and I used to give her cold tea, Violet loved cold tea.

Tom Williams was a master with horses - he'd have three on a carriage and no lines. He worked his horses by command. Tone of voice. If a horse wasn't doin' his whack he'd shout his name. When he wanted a horse to turn right he'd shout, 'See!' Jack Wozencroft 'ud shout, 'Oot!' But both of 'em would shout, 'Come here!' when they wanted a horse to turn left.

Jim Griffiths

Parkend sawmills had the recreational ground to provide hay for the horses and the men had two hours on scythes before they did their day job.

The ostlers had it hard. They started at five in the morning, fed, groomed and harnessed the horses and they'd walk those horses as far as Chepstow to get a load of timber. Pull a load of timber out, load it and then walk the horses back. And one day, one bloke was that tired, he was sat on the shafts and by the Rifleman's at Lydney he fell off and the wagon went over him.

Len Russell

CHAPTER 11

Migration

Stanley Park, Selsley, Stroud, where Mary Griffiths (Hart) worked. 'It was a big house ... I was under housemaid.'

Mary Griffiths in 'afternoon clothes' (from 2pm).

In the 1920s and 1930s there was very little employment for females in the Forest. A few found employment at home and of these a number became dressmakers but the majority had to go outside the Forest to make a living. Many went into domestic service - a large number to Cheltenham to the colleges, hotels and large houses.

Most girls went into service in Cheltenham. Buses ran on special Sundays so that they could visit their homes for a few hours, but a lot only came home for Mothering Sundays. Very often when girls were sent into service their mothers would rig them out (on tick) and when the girls got money they would send so much back regularly to repay their mothers.

Mrs Goddard

I went to Bristol as a tweenie when I was fourteen and was paid seven and six per week but at monthly intervals. I came home for one day every three months. I was treated pretty good except by the cook. When I'd done the washing-up and put everything away she'd use it all again. And she'd put lots of soda in the washing water - 'You've got to have it', she said - it made my hands so sore I dreaded it.

I had to be down by 7 a.m. - prepare the breakfast, do the grates - we'd have our own breakfast at about eight-thirty - then clean and polish the silver: I was on duty all day, but it wasn't ding-dong all day, get all the jobs done by 9 p.m. and then straight off to bed - otherwise they'd be shouting for me to go to bed.

After two years I went to Norton Court, Tewkesbury with a slight increase in wages, then back to a place in Bristol and then to Bristol Mental Hospital in Fishponds when I got twelve and sixpence a week. Later I came home and went into a munitions factory in Hereford, travelling by the works bus.

Dorothy Foley

I left school when I was fourteen and went dressmaking at Drybrook for two years. I left there to learn cooking and went to Woniston Court, Monmouth. We all went to see the unveiling of the Rolls statue in Agincourt Square. I also saw the river overflow and flood the streets of Monmouth. After two years I went into service at the girls school at Cheltenham.

Just over twelve months later I came home on holiday and I didn't go back - I got married instead.

Amy Hale

I became an apprentice to dressmaking when I left school but most girls went into service. Many of them had a bad time and said if they'd had their time over again they'd never go into service and they'd see that their daughters never went into service.

Annie Lewis

I had a job with the Marling family at Selsley, Stroud. It was a big house with a big garden - there were twelve gardeners. I was an under housemaid and was treated very well. I had a half-day every week and every other Sunday free but no other time off and was paid thirty shillings per month.

I started off as a between maid in Derby, I had to be downstairs at 5 a.m. to clean the Eagle range. There was a big wooden sink at this place. Copper pans - get things clean and the cook would get them all dirty again. When they had dinner parties I was working until 11 p.m. because all the silver had to be cleaned before we were allowed to go to bed. Asparagus - it stained the silver terribly.

Mary Griffiths

I went to Bristol as a housemaid at Clifton High School. I rose at six in the morning - my job then was to take each girl a can of hot water, then we had to see to breakfast for all the girls, lay the tables and wait on them. Next we had to clean all the ware - oh, the work was

Mary Griffiths in 'morning clothes' (from 5am to 2pm).

hard but the food was good - we had a half-day off on Tuesdays and every other Sunday afternoon. My wages were six shillings a week, but when I said I was going to leave it was increased to eight shillings.

Doris Harvey

Men as well as girls went outside the Forest to seek employment. Several Forest colliers went to America in 1904. Some Foresters went to the South-East Ohio coalfields. Others went to the Yorkshire or the South Wales coalfields.

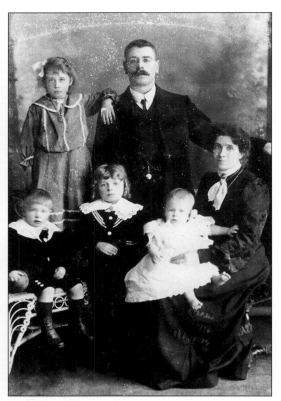

The Hall family. This family moved to Yorkshire where father worked in the Yorkshire coalfields.

My father was a miner, he and other members of the family went to Yorkshire to get jobs in the pits, but, unlike the rest of them, he came back. My mother's father, also a miner, went from Steam Mills to Wales, and I had an uncle in Wales.

Jim Griffiths

Len Davenport worked at Eastern and was up to his waist in water for six months. Then he went to London and got an even worse job. He got employment digging a tunnel under the Thames for the underground railway. He worked in a bubble of compressed air - the compressed air was to keep the river water and mud out of the tunnel as they worked - they could see the water and mud from their workplace. They worked two hours on and then two hours off when they went into a special chamber to be decompressed before going back to work. They had a pound of steak and two pints of milk a day.

After the 1926 strike the working days in the deep mines were reduced still further. At this time there were four and a half thousand men and boys in Forest pits. Men and their families began to leave the Forest, some went to the Yorkshire mines, others went to Coventry or other manufacturing areas. Houses and possessions were sold to raise money for moving. My mother could have bought a stone built cottage for £90 at the rate of £10 down and five shillings a week with no interest charges. But a year later we went to London.

Uncle Stan married a lovely Gypsy girl and went to Wolverhampton. Uncle Harry, his wife and son went to Cheltenham, Aunt Sarah and family and Aunt Lil moved to London. In my retirement I have returned to the Forest with my wife who was a Londoner. It was the pull of the Forest that brought us back.

Harry Roberts

Jim Griffiths went to Sussex, 'To get a job. I had a brother-in-law on Lord Gage's estate and he wrote and told me there was a job going on a farm, so I went'. Later he worked on a farm at Quedgeley, but on retirement, he like so many other Forest exiles, most of the girls who went into service included, felt the pull of the Forest and returned.

CHAPTER 12

On the land

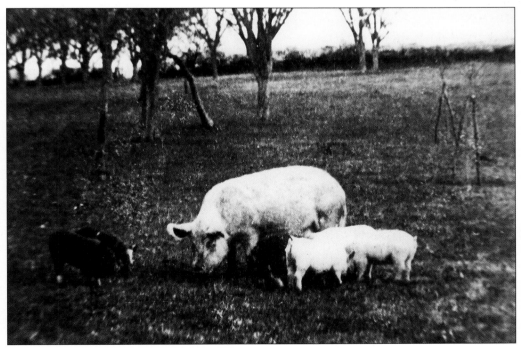

'Almost everyone kept a pig or two.'

Jim Griffiths.

The Scythe

The main things about using a scythe was putting it to cut, keeping the heel down and the point up. You took a six foot swath and cut nine inches into the grass. There'd be three or four out in the field clover mowing, the fastest mower in front and the next fastest at the back - he'd be first next time round. If you could cut an acre of grass a day, you were a good mower.

Women with pikes would shake out the grass and later they'd hatch it up with rakes - putting three swaths into a wally. If the weather wasn't good and if the grass wasn't fit for ricking it was put into cocks.

A.J. Watkins

The Estate

I started on a smallholding on May Hill, then I went to Home Farm, Huntley and worked with horses. Six a.m. to six p.m., six days a week and twice to the farm to feed the horses on Sundays. My wages were eleven shillings a week, we had four bank holidays but no other holidays during the year. We didn't wear gum boots, boots and leggings we wore in those days.

The estate produced thousands of pit props for Lightmoor. Two men and two horses loaded the poles from Newent Wood and the next day they'd take them to Lightmoor. One of these men was very fat, and the other very thin; one swore a lot the other never swore, and they worked together for years.
Cider? Eight pints a day was a man's ration.

Before the war the gamekeeper reared over two thousand pheasants each year. I've seen the lawn at the Manor covered with ladies in long white clothes, while the men played tennis.

A.J. Watkins

Sharpen Your Tools

You had to learn how to sharpen your tools. You had to learn to sharpen a hedgebill, hook, scythe, whatever. If you couldn't sharpen your tools you couldn't do the work. Later on I went to Sussex to work and the boss said to me one day, 'I want that little paddock cut, but I don't suppose you can set a scythe.' And I set the scythe to suit myself and then I started to sharpen it. He turned and walked away and didn't stop to see how I mowed that grass. Afterwards I said to him you didn't stop to see how I mowed that grass. 'No,' he said, «as soon as I saw you sharpen that scythe, I knew you could do it.'

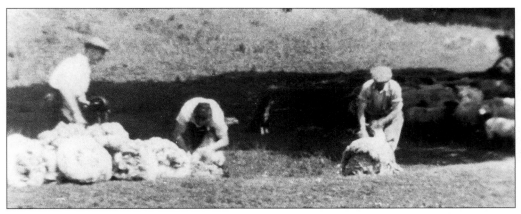

Sheep shearing at Mount Pleasant.

I'll tell you another thing. You remember how we used to have to cut all round with a reap hook before the binder went in. Well, I always liked to do that with a scythe, it was a lot quicker. And then there was the stooking. We had no weedkillers then and I've had my arms raw to the elbows from the thistles in the corn. And it was just the same when we were pugging the hay ricks to shape them up. I've had my fingers full of thistles.

It was all different years ago. Horse ploughin' for instance. Tom Williams and his horses, they looked as though they were hardly moving when they were ploughin'. But the secret of good ploughin' was no rushin' and no strainin'. Old Tom and his hosses, they'd keep dodderin' on. And hedgin', you laid the hedge and dug the ditch and the spoil went where you pleached the hedge.

Jim Griffiths

Haymaking

You'd be up at half-past three or four and you'd get your horses and you'd be out mowing before it got too hot and it was lovely at that time in the morning. I can remember seeing as many as ten or twelve men hand turning the swaths. You'd have wooden hay rakes and walk behind each other and you'd 'whip' the swaths. It was a knack and you'd have to go round the same way as the mower and then it would all roll over like a sausage. It was an art, everything was, and you didn't dawdle. Left, right, left, right, and your rake goin' with your step. If the weather looked doubtful you'd cock it, using pikes - everyone had their own pike and stuck to it - nobody else dare use yours. We had the colliers to help with the hay, they were nearly always on short time in the summer.

Arthur Holder

Sheep Badging

When I was a young boy they handled sheep differently. Grandfather was a dealer for this area, he'd go to Brecon and bring back four or five hundred ewe lambs, if any wether lambs had got in with 'em by mistake, he had them free. You'd put a bell round the neck of a fresh lamb and when we

Harvey Gwilliam shearing.

A Longhope Farm

Not many farmers had any money in those days, some farms had no road, several farms had plenty of water in the winter but none in the summer. Out of fifty acres we grew fifteen acres of mustard every year and ploughed it in, like that we could grow wheat very well. And ten acres of potatoes, they cleaned the ground. In those days we could grow crops without artificials or sprays.

A Smallholder

Tom Bullock, a smallholder near us only had a little bit of land and only ten cows and a milk round, a sow and pigs. He fed the cows and pigs on grains from the brewery just up the road. Then he got a bit more land. He sent his milk to Gloucester Farmers at a shilling a gallon. But he and his sister made a living, it was wonderful what they did.

Fred Few

bought a score of lambs we did 'haunt' 'em out in the wood - we'd sit with 'em til they lay down and then we'd creep off home. We always brought 'em back for lambin' and shearin'. And there was a communal dip at the Branch.

When a lamb first had a bell it jumped and jigged about for a while. We had a bunch of lambs in a wood near Steam Mills and at night they'd go up through the wood by Slad school to Joys Green and we'd have to bring 'em back. Father was at Crump Meadow and the engine man would stand on the tump for his break and his bread and later he'd say, 'Alf, they be over at Joys Green again - I heard their bell as they went by Slad School.'

Gilbert Roberts

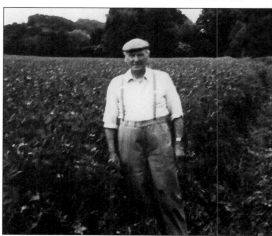

Fred Few.

106

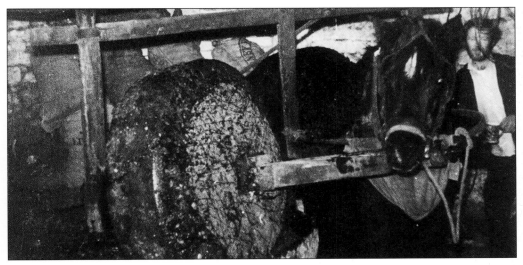

Cider making at Edge Hills.

Cidermaking

On our farm we had about fifty Blakeney Red pear trees - huge trees, some bore a ton of fruit apiece. We also had some French fruit. Every year we made three thousand gallons of perry and cider. We sold it in four and a half and nine gallon casks - the free houses bought it in sixty gallon casks. We delivered it by horse and cart on Friday nights - into the woods to miners and so on. Our cellar and mill house were full of cider. Dad got fresh casks, port wine and rum casks from Manchester, every three years and scrapped the old ones which gave a woody taste to cider if a drop of cider had been left in them. This formed a crust on the sides of the barrel and the ends had to be taken out to clean them - sometimes we put beet in the barrels to eat up the acidity. Once an old sow got at the crust and there she lay drunk and squealing as if she'd been stuck.
When we were haymaking men came in to help and they were given cider - when they left some of them were drunk. We had to get the doctor when they'd fallen down and cut their heads.

Fred Few

Once a year a cider making machine came, it was stationed at Orepool and local people took their cider apples there to be pulped.

Mrs Goddard

Cider making time - as a boy I used to follow the horse round the cider mill, that was usually a night job. Neighbours came to help - and to drink cider. Round and round the mill wheel went until the apples were crushed and their kernels smashed. Then it was put in between horsehair sheets on the press making what we called a 'cheese'. You folded the sheet over after the pulp was put in and then another sheet - eight or ten altogether, then you screwed down the press, the juice ran for days into a stone trough and then you screwed the press down tighter and it ran some

more. The juice was bucketed into huge wooden casks. You didn't put anything else in, it worked of its own accord for weeks - the bung was left out and it frothed up through the bung hole. You kept pouring a drop in to keep it topped up and when it stopped frothing you put the bung in and waited for it to be ready to drink, which was some while.

Arthur Holder

Hedge Laying

David Warren was a farmworker, one of the old sort, a skilled workman who could turn his hand to any job on the farm. He never appeared to hurry - he conserved his energy instead of wasting it - and for a long and strenuous harvest day he'd be working at the same speed at nine o'clock at night as he was at nine o'clock in the morning. He worked with a rhythm which lightened his labour and which seemed deceptively slow yet achieved a lot. His especial skills were thatching and hedge-laying.

First you rid your hedge, clear out all the rubbish, the stuff you don't want, leaving the sticks you want to pleach. Then you pleach 'em with a nice clean long cut with the axe if they'm big or the billhook, and you pleach 'em right down to the ground and cut the snag off. No, you don't want saws when your hedging. And you drive the stakes in at an angle - not with a ring bittle or an axe as some do, that only makes the top of the stakes look like shaving brushes, use a stake bittle, and you don't use any live stakes - that's unforgiveable. All the sticks are laid uphill - so you start layin' at the highest end of the hedge. Neither do you bend a live stick - you ain't makin' wattle hurdles - and you lay 'em all with the brush on one side of the hedge only. Nor do you stuff the hedge with dead stuff - that wun't grow - nor too tightly, when you've finished a blackbird should be able to fly through the hedge. If you want to hether the hedge you put your stakes in straight up and use a hethering stick to every stake.

David Warren

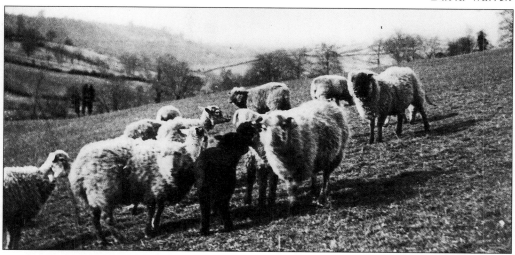

'We did haunt 'em for a time.'

CHAPTER 13

Blood on the coal

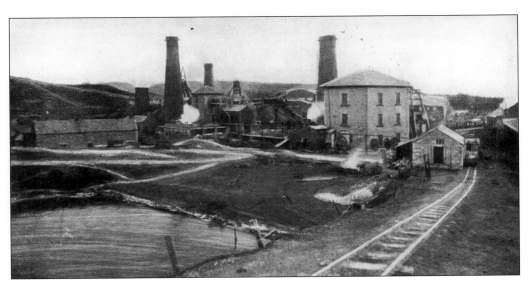

Lightmoor Colliery. 'Yes, I expect it was the best pit.'

My father worked in the pit and died at fifty with silicosis, which was then called 'colliers asthma', you never got anything for it in those days. Thousands and thousands of men have died from working in the pit and that from bad air, powder, smoke and all the rest of it. My father was gasping for years before he died just before he was fifty.

Albert Meek

As we did take the coal out, we did say, 'im's a throwing his weight, you could hear it up above goin' like thunder, but after a time it didn't worry you, you got used to it. You had your stacks up under the rocks and the tops of they would fazz over, just like a mushroom. The horses and the rats could tell you when it was time to get out from there. The waste used to go into the sides and pack that to keep the roof secure. The rats used to get in there and when it started to come down the rats would start to get squashed and they'd start to squeal. And the horses, they knew. If they were coming up the road, bringing the carts in and out, if there was any danger, they'd start pawing the ground with their front feet. And if you took their chains off they were gone, and then we could get out. They knew danger.

Alan Drew

Candles were done away with and they started using oil lamps. The paraffin used to smoke in those days, it would smoke but it was cheap, a penny a pint. Then carbide lamps came - but it was a bad thing in a way, it was poisonous. The men got trouble with their breathing. Half-way through the shift, the lamp had to be re-filled and they'd go to the road and knock it on the sides to get the old carbide out and there'd still be a lot of fumes in it. It had a nasty smell. It was a thing that was very vile and it affected the breathing. Lots of men had to go out of mining, they thought it was bronchitis but it was brought on by carbide which was very poisonous but gave a far better light.

We never had safety hats. A man called Taylor at Crump Meadow was working with the shift man - it was the water pit. It was on a Sunday, when the pit was idle and they were working on top of the cage. The top was dropped down flat to work on and they were just below the top of the mine and it was light there. And Mr Hicks said, 'Harry, pass me the hammer'. But there was no answer and so he turned round. Harry wasn't there. He must have slipped off the cage and shot straight down the shaft. Mr Hicks, he climbed down the guide ropes, he went straight to the bottom to look for his mate and found him in pieces. They shovelled him up and put him in a sack.

Explosions caused the most accidents in mining, but Foresters were killed at their places of work, sometimes from negligence. Roof timbers sometimes gave way or there was a runaway. I remember Ivor Baldwin being killed at Crump Meadow, in the road where I was working with my father - we were working the Brazilly sea. His brother was cutting at the coal and a piece of the roof fell across his neck and broke it - Ivor Baldwin was killed straight off. No, the widows got very little compensation. In those days we were classed as animals and got treated as such. They were bad old bosses and you had to beg for bread.

Jesse Hodges

Parkend Deep Navigation Collieries, Ld.,

ACCIDENT & DEATH SOCIETY

STATEMENT,

FOR THE YEAR ENDING DECEMBER 31st, 1893.

PAYMENT TO INJURED.

Name	£	s.	d.	Name	£	s.	d.	Name	£	s.	d.
Bath, A.	0	10	6	Joynes, R.	0	10	6	Preest, W.	0	9	0
Beach, J.	0	18	0	James, J.	2	11	0	Phipps, C.	1	5	6
Barnes, Joseph	0	16	6	James, T.	4	1	0	Preest, Hosea	1	8	6
Blanch, S.	1	10	0	James, H.	1	16	0	Prout, W.	1	1	6
Biddington R.	0	15	0	Jones, A.	0	12	0	Ruck, J.	0	13	6
Berry, W.	6	16	6	James, Jesse	0	9	0	Russell, J.	1	11	6
Blanch, James	0	10	6	Jefferies, T.	0	4	6	Richards, Alfred	0	18	0
Brown, E.	0	12	0	Jones. T.	0	4	6	Russell. T.	1	13	0
Beddis. C.	1	16	0	James, C.	0	15	0	Richards, T.	0	4	6
Cole. F.	0	18	0	Jones, F.	0	19	6	Smith, E.	2	2	0
Craddock, W.	12	3	0	James, Amos	0	15	0	Stephens, J.	0	18	0
Cooper, Henry	0	9	0	Jones, S	0	12	0	Smith, Levi	0	18	0
Charles, E.	0	15	0	Kear, W.	0	18	0	Screen, Robert	2	3	6
Charles, Alex	1	7	0	Kear, A.	1	2	6	Thomas, J	0	13	0
Cox, Thomas	0	12	0	Lee, Thomas	0	7	6	Turner, W	0	12	0
Childs, G.	0	9	0	Lowe, J.	1	5	6	Turley, R.	0	15	0
Childs, James.	3	6	0	Lane, W.	0	13	6	Thorn, G.	0	9	0
Duffty, Thomas	0	9	0	Lewis, W.	0	9	0	Thomas, J.	1	8	6
Dobbs, Rees	0	6	0	Morgan, W.	0	10	6	Turley, James	0	18	0
Ellway, W.	1	10	0	Morse, W.	0	7	6	Turley, Joe	1	11	6
Edmonds, George	0	8	0	Morgan, Richard	3	13	6	Underwood, J.	1	2	6
Evans, J.	0	15	0	Mansell, W.	0	7	6	Well, Thomas.	0	4	6
Embrey, Thomas	0	9	0	Mansell. C.	1	1	0	Watkins, W.	1	8	6
Gennel, Henry	0	16	6	Moulton, W.	0	13	6	Willetts, T.	0	9	0
Gaudern, Henry.	1	2	6	Morgan, A.	0	16	0	Wintle, Mrs. (widow)	6	15	0
Griffiths, S	0	6	0	Organ, D.	0	18	0	Wright, E.	4	17	6
Guest, I.	0	7	6	Pearce, Dan	0	9	0	Wilding, Richard	0	15	0
Hale, E.	0	18	0	Preest, C.	1	1	0	Wintle. Alfred	0	9	0
Howell, Henry, sen.	2	14	0	Phillips, Richard	0	15	0	York. W.	0	12	0
Howell, Henry, jun.	0	16	0	Powell, C.	0	16	6				
Howell, S.	1	7	0	Phipps, Henry	2	2	0	£117	10	0	
Hewlett, T.	0	15	0								

BALANCE SHEET.

Jan. 1st.		£	s.	d.			£	s.	d.
To Cash in Capital and Counties Bank, Lydney		392	2	8	By Cash paid to Injured		117	10	0
,, ,, Treasurer's hands		3	16	11	,, ,, Secretary's Salary		6	0	0
,, Subscriptions from Members		176	18	10	,, ,, Cooksey, Printing		1	6	6
,, ,, Outside		3	12	3	,, ,, Gloucester Infirmary		10	10	0
,, Interest on Deposit		9	13	3	,, ,, Loan to Relief Fund		100	0	0
,, Part Repayment of Loan		17	4	8	,, ,, Deposit in Bank		301	15	11
					,, ,, In Treasurer's hands		66	6	2
		£603	8	7			£603	8	7

RELIEF FUND.		£	s.	d.	LOAN ACCOUNT.		£	s.	d.
Dec. 1893					Dec. 31st, 1893				
Loan to Fund per Mr Rowlinson		100	0	0	By Repayment, to date		17	4	8
					,, Amount due to Club		82	15	4
		£100	0	0			£100	0	0

We have examined the Accounts of the above Society, and found them correct as per Balance Sheet.

Signed, { THOMAS BLANCH,
{ JOHN HAMPTON.

Committee :

LEVI SMITH, GEORGE THORN, HARVEY SUMMERS, JONATHAN BIRT, ISAAC JONES, ELIJA SAYCE, THOMAS ROBBINS, ALFRED WINTLE, JAMES PAGE, WILLIAM FLETCHER, SAMUEL ELLWAY, T. H. DEAKIN, Treasurer. ALFRED MILES, Secretary.

Rescuers at the Waterloo flood.

The new Fancy cage was not that much different from those at Lightmoor, Foxes Bridge and Crump Meadow. It held about eleven men and boys but you were packed in like sardines. At the Fancy there were two bars to hold the men and boys in the cage. The lower bar, at knee level, was fixed. The top one lifted for them to get out.

At the Fancy there were two cages in the same shaft and they'd pass half-way and half-way up a cage might sway about twelve inches, which was all right if the other wasn't swaying the same way. On one occasion it did and both cages came together and locked solid. There was a little grunt of surprise from the men, but one man in the middle of us panicked.

I've never seen anyone in the mines panic, except this time, they were always so casual about any calamity. But this man, middle-aged and with a family, he went mad and tried to get out. He could hardly move, but he did throw his arms about hitting people. The others beat him unconscious to shut him up and because we were packed in so tightly he couldn't fall over, his head just flopped down.

A man came down on a rope ladder, he came down one-handed because he had a four pound club hammer in his right hand. And he was chattering away like anything. I don't know how many hundred feet it was but down he came and banged at the cages. The water was pouring out at the sides because it was pretty wet in the shaft. And he chatted away to us and when the cage was freed it went with a bit of a thump and the man on the rope ladder gave a signal and the cage went up and him rolling up the ladder and chattering. And we came up drenched with water.

Another hazard; they'd start taking the last bond underground, ten or twelve drams of coal. There'd be no indication, no bond rider on this run, only one door to open and the first dram did that. The hawser wire would tighten and, oh, if anyone was straddling it! As it was an endless rope there were two of these to contend with and as tension increased they'd slap on the roof. And you'd have to squeeze against the side and no man holes to get in and dozens of men walking out, I don't know how they didn't get knocked out.

Then there were the horses coming out, they knew they were going back to the stalls and they'd be going at a rate. As soon as they were unhooked they'd go like racehorses and in the dark. How

they got through the air doors I don't know. Fortunately up the dipple there were manholes when three horses came rushing towards me on one occasion.

I think one of the worst things was when we used to run out of air, run out of fresh air, and in spite of the braddish doors [air doors]. It seemed that the ventilation system used to break down and suddenly the candle flames went down. Miners had these candles to have a constant check on the air. The candle flame gets shorter and shorter and it goes to about a quarter of an inch on top of the wick and with a further reduction of oxygen the flame suddenly goes two inches above the candle. And between that flame and the candle there is nothing to be seen!

We had that exact condition and the two butty men - Charlie Evans and Cornelius Evans - came down and said, What be thee gwain to do then, ole butty?' And I said, I'll do the same as you do.' Right, lie on the floor'. And we lay in the dirt and watched that candle, we watched for twenty-five minutes. By then we were sort of breathing and not breathing anything. We had done a bit of panting and we got cold with it and we knew it was a good mile back to the pit bottom. I don't think any of us spoke a word in that time, we were too intent on watching that flame above the candle. Suddenly that quarter inch flame jumped back on top of the candle and within five minutes it was half an inch long and we knew that the ventilation had been restored. Perhaps I didn't realise the danger at the time. The two butty men said, Right, now we can go back and earn our living.'

Harry Roberts

Black damp. We put candles up to the roof between settings and if the flame went out, it was time to get out.

Eric Warren

We were working at Foxes Bridge the day Ben Ensor got killed. He was a forcer - getting the stuff back. It was a nasty road and him had got to force the horse on, and a tongue [of the cart] sprung loose, the cart jumped and hit the setting out. The top setting came down on him.

Alfred Warren

Ben Ensor had two brothers, both Forest miners, one died quite young from 'miner's lung', the other had his spine fractured at Eastern United and died two days later. Their father died of 'miner's lung'.

We were on our way in the lorry to the New Fancy and we were held up near the Dilke Hospital. In the headlights we saw a small group of men and they were carrying the remains of a man who'd been killed at Lightmoor. They were carrying him in braddish and they went across the road to the Dilke - but they said the man was in pieces.

Harry Roberts

Roy Griffin was running under the bottom of the pit (at Cannop) when the cage came down on him. I pulled him over and put him as he could breathe - his ribs had punctured his lungs and his eyes seemed to be down on his cheeks. Another time a man was buried on the coal face - couldn't see him, but I managed to cut right round him and after a bit I got to his head. I cut round him with a hatchet. There was a hole in his hip where his 'bacca box went in to him.

Harvey Gwilliam

Falls of roof accounted, I should think, for about half of pit accidents - much more dangerous was the coal itself. As you were getting the coal out it would come over at you at great speed because of the pressure of the roof - it would squidge out. Oh, accidents from shot firing. I saw a man's eyes blown out and his carotid severed. One had coal shot right up his ass. And there were accidents with carts and haulages, perhaps a cart would come unhitched and some gradients were as much as forty-two per cent. That's steep y' know.

Where it was rough and dangerous not so many got hurt as you might think because extra care was taken in those places. There were lots of accidents at Eastern because the rock was open to abuse - men took chances.

You could test a roof in three ways. By sight, (looking for cracks), by sound, - there'd be a hollow sound if it was detached from the main strata. But you couldn't tell with a bell - there were a lot in house coal seams, but not so many in steam coal seams. It was often the tidy collier who was killed by a bell, because he'd chip away to smooth the roof

and dislodge a bell which would come straight down.

Eric Morris

The bell can be as much as a yard across and of a bell-mouth shape, where the cavity of the bell would be is about twelve inches across and it's a petrified tree trunk and where the bark would have been, a thin layer of coal. And when air gets to that coal it starts to release itself and the bell will drop without warning.

Normally you can sound the roof and know if it wants timbering immediately. But you can't do that with a bell, you can tap it but get no tell-tale response. You've got to get a timber up real quick with a bell.

Sparks we called him, he was only eighteen years old, well, one day at the Fancy he went up an old road, an old working disused, to relieve himself. He pushed open the air door, it closed behind him as he walked on a little way along the old working. That was the end of him, he died in that old working for lack of air, or perhaps stale or foul air killed him.

Harry Roberts

The water came in from the old mine up in the wood. I was one of the last to get down to the pit bottom, look. You know, I had to get in water right up to my waist and then get to some trams of coal and a fellow named Bert - him was the pit man, look - and him did tell me how to crawl from one tram to t'other. Ha! - Ha! I shall never forget how we got out. [Flooding at Waterloo]

John Wynne Griffiths

The Union Pit disaster occurred in September 1902. Water broke in from an old working on Thursday, 4 September. The water flooded the pit, sweeping away timbers and trapping several colliers. Four men lost their lives, the eldest was thirty years of age and had four children. Two colliers were trapped in the pit for one hundred and twenty hours before they were rescued.

My father worked with one of the survivors of the Union Pit flooding. He was trapped in there, he said, with an old man who he wrapped in braddish to keep warm but the old man died. When his light was exhausted he lay down on his side to die and then he heard tapping. In the darkness he felt around and found a clumper and tapped in answer to the tapping he'd heard. And then that tapping stopped and he thought they hadn't heard his tapping. But after a while the tapping started again and so he started tapping again and made contact with the rescue party and they eventually rescued him.

After they'd got him out on top they took him home. They took him to his garden gate and he insisted upon walking up the garden path alone. His wife was standing in the doorway of the cottage. She looked at him and then dropped dead.

Eric Warren

I am afraid I have left too much of my blood in the mine ever to want to go back down and I would not wish it on anybody. I don't believe God meant for a man to grovel in the bowels of the earth and to leave blood on the coal, and I left plenty. When I look back to the days of my youth in the mines, to the grovelling in the bowels of the earth and to the terrible work, the hard work, the sores, the bleeding, the crying, the parents saying, 'I can't help you, son'. One had to go down to bring up the rest.

Jesse Hodges

CHAPTER 14

The lighter side

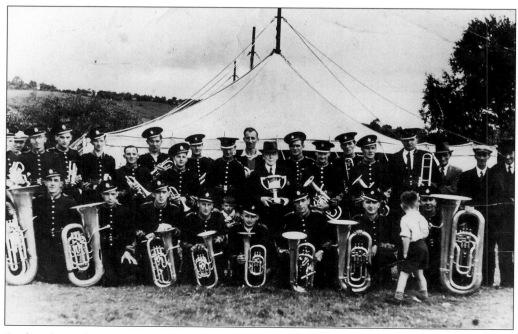

Drybrook Band, winners of the Ruardean band contest in the early 1920s.

Demonstration Day

The first Forest of Dean Miners' Demonstration Day was held in a field adjacent to the Speech House on Saturday, 27 July, 1872. With the agreement of the employers all the Forest pits closed upon that day. About four thousand colliers marched behind bands, the procession was one mile long. 'A great demonstration of colliers and unionists . . . six bands'. Wives and children joined them at the Speech House; in all, the demonstration attracted between twelve and fifteen thousand people.

Demonstration Day with its speeches and amusements was the great day for colliers, their families, and other Foresters until World War Two ended it.

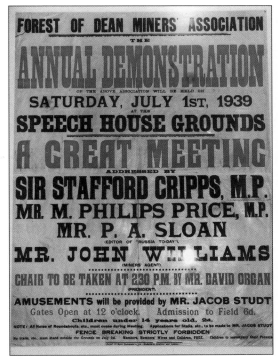

The last demonstration.

The bands, stalls, fun fair, the speeches by miners' leaders, other unionists, politicians - buses on the run all the time, they came up from South Wales, the place was packed with people - thousands of them.

Alan Drew

The worst day's work ever done was when the Demonstration finished. From Ruardean Hill we used to walk through the woods to Speech House. There'd be the meeting and the roundabouts and all that. It was a real day out for the miner and his family, it was lovely, we didn't half enjoy it.

Amy Adams

It was quite an event. Miners from beyond the Forest came, the Welsh miners came, there were thousands there. Swings and roundabouts and fern tickets - off into the woods with a girl. There was some beer and stuff drunk there, I can tell you. The bands played and when the speeches were over there was dancing. It was all lit up at night, it was a wonderful spectacle.

Cyril Elsmore

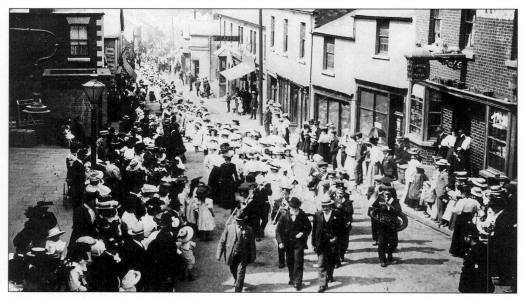

Co-op Penny Bank Treat, Cinderford.

The big day in the Forest, I went lots of times, because my father was a miner it was the one day of the year when our relative in London used to come.

It was the first Saturday in July, we walked from Newham Bottom. I believe it was the highlight of my father's year, mixing with his pit mates and listening to the speeches. Oh, there'd be thousands there, thousands, thousands and thousands. It was the big day in the Forest, everybody in the Forest went. No, I can't remember any of the speakers or what they said, I was very young in those days. My father was very interested in the speeches, it was the miners' gala day. And that was the day when they got the fern tickets. We boys used to pinch the wooden balls that were chucked at the coconuts - we used to whip 'em, yes, and use 'em as cricket balls.

Jack Pritchard

Of course, it was the miners' day. They had their own agent and one of the big Labour leaders would come and after the speeches the fun started. The fair lit up, there were the usual things and a roundabout with dragons instead of horses. And the old organ would be belting away, even the organ was driven by a steam engine, puffing away. There were stalls and catchpenny things, little shows with naked ladies and boxing booths, you bought gingerbreads, cherries and things and you got your fern ticket. These fern tickets gave you permission to miss your road coming home and get lost in the fern. Everybody that could walk there did walk but some would ride - Dan Walkley had two wagonettes and you could ride for a penny. At the end of the day there might be a few fights - some of them would be a bit far gone with beer and one thing and another.

Arthur Holder

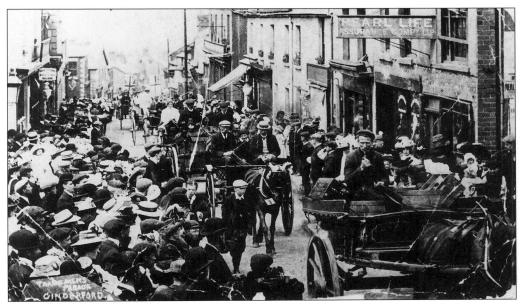

Whit Monday Tradesmen's Parade, Cinderford, 1909.

Penny Bank

The day of the Co-op Penny Bank Treat was a big day for children. We all used to march along with our mugs tied around our necks.

Elsie Olivey

I was up at six o'clock in the morning, cutting up and putting the food in big clothes baskets. We used to have some lovely times doin' that - lovely times we had.

Amy Adams

Most everybody dealt at the Co-op - everybody was glad of this bit of dividend every quarter, it bought your shoes and clothing. And the Co-op ran the Penny Bank as we called it. It was a day out, the Penny Bank parade and tea. It was on a Thursday in the summer and everybody walked or got to Cinderford somehow. We used to have a bit of a bunfight, sandwiches, bags of cakes, races. The Co-op used to deliver with a big dray and horses and for some reason or other the horses bolted once. They ran away at Nailbridge and ran down the bank where Jim Hale's got his yard now and all the bread and cakes were all spewed all over the place.

Jack Pritchard

119

Milkwall and District Charity Committee, organisers of Band Sunday.

Hospital Sundays

We had Hospital Sundays. The Milkwall and District Charity Committee collected money to be distributed to the Dilke, Lydney, and Gloucester hospitals. It collected hundreds of pounds. Joseph Pope was chairman, one of his teaching staff known as Spriggy Rosser was secretary and Dick Dowler was treasurer. The members, all men, were from Coalway, Fetterhill, Ellwood, Milkwall and Sling and meetings were held at the Mission Hall at Milkwall. There'd be as many as nine bands - Berry Hill, Parkend, Coleford, Lydbrook, Bishopswood, Two Bridges, Lydney, Newnham, Littledean, I think - at the bandstand at Sling. The bands marched in and played - there'd be hundreds of people - it was a grand sight. At the end of the concert they marched in line to Scarr Farm at Milkwall where ther'd be trestle tables, four or five niners of beer and snoules of bread and cheese cut up by the women.

Some would sit there to midnight a counting the money and some of the bandsmen would sleep in the hay.

Cyril Elsmore

Drybrook Band

The band started, re-started, in 1926 and won the first contest at Ruardean about 1926 with *Dawn of Spring*.

It was very hard times then, no money, colliers weren't getting much money. If anyone was ill or anything, everyone clung together - that homely feeling! We hired instruments and walked to Mitcheldean, Huntley, Ross and played to collect money to buy our own instruments. Christmas '24 Or '25 we collected £56 - a complete set then cost about £150. We had wonderful times with the band. I and two others

120

The Pludds. The Royal Oak 'Bag o' Nails' Club Supper, 25 September 1926.

from the Drybrook Band played at the Crystal Palace, London, with the Ross Band. There were crowds in the streets that morning when we boarded the bus. Beer and cider were taken and you can imagine what it was like when they got on the stage. I wanted Drybrook to play at the Crystal Palace but it got burnt down. But we did play at the Alexandra Palace.

Stewart Harris

Quoits

Its proper name was Royal Oak but everyone called it the Bag of Nails. Uncle Tom kept it for years, they used to do a lot of singing there. Quoits was played just below, on the Gill Ground, a disused quarry. The quoits were made of iron and the middle peg was called the 'meg'. Oh, there'd be as many as forty people playing there.

Lewis Hale

My father, Tom Reid, had the Bag of Nails. Quoits was the thing. The Pludds had a team and Hawsley, Brierley, Ruardean Hill, and Ruardean Woodside had teams. There were eleven players in a team. Enoch Bradley of the Roebuck at Ruardean Woodside was a champion player, he had some heavy quoits, five, perhaps seven pounds in weight and he played the champion quoit player of England at the Bag of Nails and won. The quoits beds were made of clay and before a match the clay was dug up and watered and then knocked down fine. The first player pecked [threw] his two quoits at the meg and then the other players did the same. Sometimes the quoits were so near a pair of callipers were used for measuring. The game died out in the late 1930s. Once we had a bit of a do at the Pludds and the Ruardean Band came and a tree was planted by my grandfather, John Reid.

Sydney Reid

121

Young men at Parkend.

Monks Parade

Every Sunday night after service at chapel or church, boys and girls used to walk up and down, up and down, from Lambsquay to Watkins' factory, backwards and forwards, backwards and forwards. This was known as 'Monks Parade'. There were also Monks Parades at Parkend down to Whitecroft, and at Edge End.

Doreen Goddard

Sunday, after chapel, Monks Parade, Dozens and dozens of young men and women. Gangs of men and gangs of girls. Men whistling at the girls. From Mile End to the top of Worrall Hill, blokes trying their luck following the girls.

Len Russell

When we came out of chapel we joined all the rest and went across what was called Monks Parade - it started at Mile End and went to Edge End. You met friends there - people came from as far away as Bream, some cycled from Monmouth. They paraded in groups all along the road. In the winter you might have some kind of light but there weren't any along the road - you recognised people by their voices. Really, there were hundreds there, boys and girls, some would cycle there, some came from Cinderford just to parade along the road.

Doris Harvey

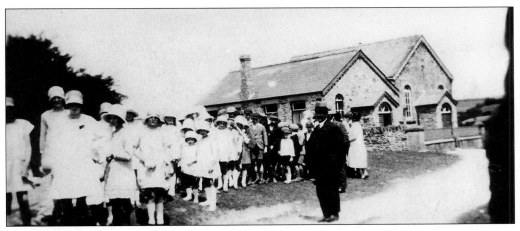

Knight's Hill Sunday School in the 1930s.

About five of us young boy-chaps went to Cinderford and we met this girl. One of us had been out with her before and he thought he could carry on as before. But I said, 'You can't take her home just like that, we'll toss for it', and I won. I went out with her for a couple of years.

Gilbert Roberts

From Lambsquay to Sling Avenue, also from Beeches Pub at Mile End to Edge End. Always somebody hitching up with someone.

Cyril Elsmore

After chapel on Sunday evenings, Bob Wilkins, Cyril Burris, Albert Verey and I would go for a walk round the Barn - a good place to find girls. Later we'd go to the Mount Pleasant and buy a flagon [a quart] of beer for tenpence and then we'd wait for Mr Nelmes the tobacconist, Mr Diamond, and Mr Kear the baker, who'd come in and say, 'Drink up, boys' and they'd buy us a couple and tell us all sorts of stories.

A.F. Ensor

After chapel, or church, on Sunday evenings people went for a walk. Families went up to the barn and across fields to St Whites Farm. Courting couples went from the farm gate down Lovers' Lane - which was very narrow and had high hedges on both sides. At the bottom of Lovers' Lane they went into Grange Lane and to Littledean and then back up the Ruffit.

Elsie Olivey

At Sunday School, the boys sat on one side of the gallery and we the other and we used to - oh, we used to have some fun. Go for walks with the boys after? Did us! No, not in the woods, we kept to the roads. There was no goin' in the woods with boys, our mothers would have killed us.

Amy Adams

123

The Bathing Pool Soudley.

Soudley Pond, 1937.

Soudley Ponds

Mother used to say to us, 'Don't you dare go near them ponds'. And we'd say 'No, Mam, no, Mam.' But we did. And d'you know what, the big pond at Soudley, that used to get frozen over and there've been as many as a hundred people on that pond. And a team came down from Cheltenham and one from Stroud and they did skate on there, that was in the '20s. And we used to go right back up in the woodside and we'd walk from one end of the pond to the other.

Then, they were always called Morgan's Ponds. In the summer they used to have swimming galas down there, they'd come from Cheltenham, Stroud, Cotswolds. Jack Witney, well, Jack and Bill, they were both damn good swimmers, high diving, sixteen foot diving, of course the pool at that end was fourteen foot deep. And racing, there'd be hundreds of people come there to them swimming galas. They'd put six foot bradish across the front so people couldn't come up along the road and watch it.

Alan Drew

124

Winter forty-seven

The hard weather began in the middle of January, followed by heavy falls of snow. From 25 January to 8 March the ground was frozen solid and covered in snow. Then blizzards blocked many roads and isolated towns and villages in the Forest. Every road round Cinderford was blocked by drifts of snow up to eight feet deep and food supplies became dangerously low. When flour reached Cinderford Railway Station for local bakeries it could not be moved because Station Street was impassable. Meat in the town awaiting distribution to Drybrook, Ruardean, Longhope and Newnham could not be transported. (Cinderford then had the district official slaughterhouse). Mr. A.E. Stigwood made an appeal for volunteers to clear the roads. Throughout one night between eight and ten hundred men and women were clearing the roads of snow - at midnight there were two hundred people working in Belle Vue Road. Volunteers were performing similar tasks in other parts of the Forest.

Lower High Street, Cinderford, 1947.

Down the Ruffit and Reddin Lane you had to walk on the top of the hedges. We were paid two shillings an hour to clear snow from the railway station to the Co-op to get flour and other supplies through. We used to have a warm at the gas works and then go and have some faggots at Jack Davis's, who kept open all night for the men clearing snow.

Eric Warren

We couldn't get out from the house for snow, on Littledean Hill, where we were then living. The snow was piled up to the doorways. I couldn't get to work at Eastern United, I went snow shovelling instead. We worked all night long, we had to cut a way through the snow from Cinderford to Elton Corner. And on top of the Barn the drifts were twelve to fourteen feet, one gang would take the top six feet off and another gang would follow and dig down to the surface of the road and also open all drains ready to take the water when the thaw came.

Alan Drew

Up the Morse it was twenty feet deep [Morse Lane, Drybrook]. We had to dig ourselves out and to get food through we dug from Drybrook Crossroads to Hown Hall Corner at the Lea. It took nearly a week. We were filling Howard Moore's lorry with snow and dumping it down over the cutting. Later I took Bill Brown's lorry to Cheltenham to get beer for the Hawthorns, but when we got to Over there were floods by the Dog and by the time we got to Gloucester we found we'd no brakes.

The village had been practically without food or beer. The snow was so deep people walked on the top of the hedges in some places. Oh, it was cold, when I was taking timber - it had to be carried down, one young fellow fainted from the cold. One day I took coal from Waterloo to Lydbrook Cable Works - which was out of coal - and after delivering it, it took us from 3.30 to 10 p.m. to get from Lydbrook to Nailbridge - we had to dig snow to get the lorry home.

While we'd been digging our way to the Lea, other gangs were digging from Drybrook to Mitcheldean, and to Cinderford. And where we'd pushed snow over the bank there was still snow in September.